To Diana &
with love from
the Blooms —

Marie Kimbrell

Body, Memory, and Architecture

Kent C. Bloomer and Charles W. Moore

with a contribution by Robert J. Yudell

New Haven and London
Yale University Press

Designed by Tina Beebe and set in Garamond type. Printed in the United States of America by The Murray Printing Company, Westford, Massachusetts.

Published in Great Britain, Europe, Africa, and Asia (except Japan) by Yale University Press, Ltd., London. Distributed in Australia and New Zealand by Book & Film Services Artarmon, N.S.W., Australia; and in Japan by Harper & Row, Publishers, Tokyo Office.

Figure 81 on page 61 is from *Skyscraper Style: Art Deco New York* by Cervin Robinson and Rosemarie Haag Bletter. Copyright © 1975 by Oxford University Press, Inc. Reprinted by permission. Other illustration credits appear on page 147.

Bloomer, Kent C. 1935-
 Body, memory, and architecture.

 Bibliography: p.
 Includes index.
 1. Architecture—Human factors. 2. Architectural design. I. Moore, Charles Willard, 1925- joint author. II. Title.
NA2542.4.B57 720 77-76304
ISBN 0-300-02139-9
ISBN 0-300-02142-9 pbk.

For Nona

Contents

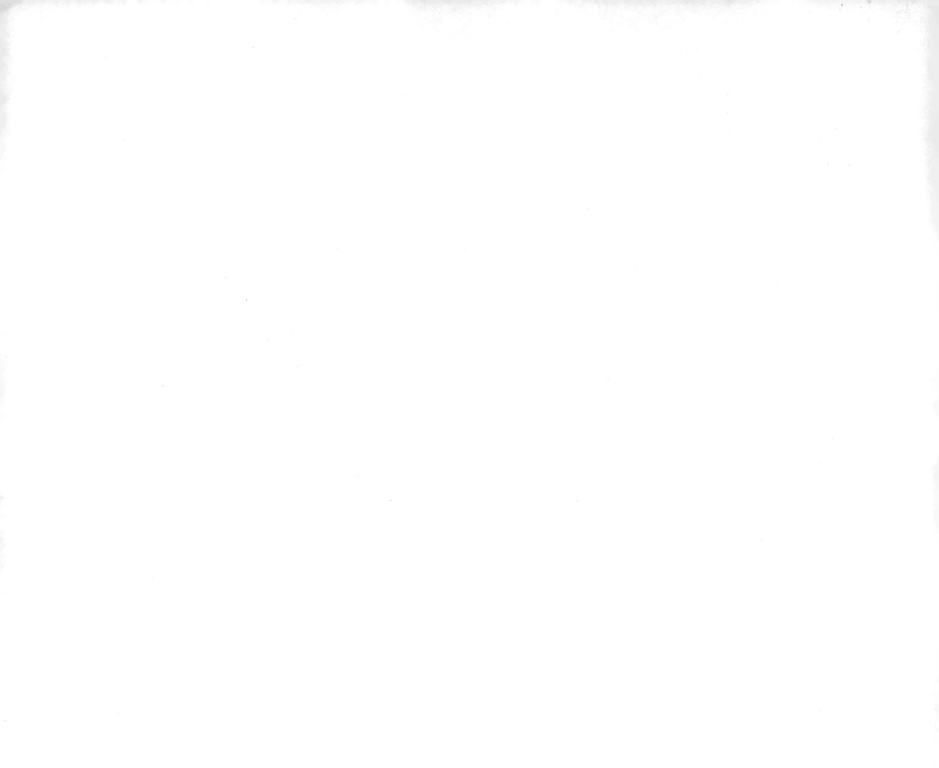

Preface

This book is a product of our joint efforts to teach fundamentals of architectural design to first-year professional students at the Yale School of Architecture. From the mid-1960s to the present we have attempted to introduce architecture from the standpoint of how buildings are experienced, before worrying about how they are built. We have believed that until we can begin to understand how buildings affect individuals and communities emotionally, how they provide people with a sense of joy, identity, and place, there is no way to distinguish architecture from any everyday act of construction.

In the course of this effort we have often found ourselves in conflict with rather powerful presuppositions about what architecture is, as well as about which areas of inquiry are deemed essential to its perpetuation as a field of study. We observed that reference was seldom made to the unique perceptual and emotional capacities of the human being; even historians concentrated on the more general influence of culture on the form of buildings and landscapes. Issues of joy and beauty were often regarded as quaint and arbitrary in the sometimes blinding light of a call for progressive development of techniques in building design and production.

It became apparent to us that behind this conflict was the general assumption, seldom debated, that architecture is a highly specialized system with a set of prescribed technical goals rather than a sensual social art responsive to real human desires and feelings. This limitation is most frighteningly manifested in the reliance on two-dimensional diagrams that lay more stress on the quantifiable features of building organization than on the polychromatic and three-dimensional qualities of the whole architectural experience. At the same time we have been observing that the human body, which is our most fundamental three-dimensional possession, has not itself been a central concern in the understanding of architectural form; that

architecture, to the extent that it is considered an art, is characterized in its design stages as an abstract visual art and not as a body-centered art.

Our book attempts therefore to re-examine the significance of the human body in architecture. In the first chapter we review a few major events from Western history as a reminder of how long the body was central to architectural thought. We suggest that only recently, during the emergence of modern academies, have architectural beliefs become so severely "rational," and we examine some controversies of post-Cartesian philosophical and psychological thought as they pertain to changing views of architecture. Our own focus is developed in the ensuing chapters, where we review some models of perception that have been influential in the twentieth century and examine in greater detail some implications of body-image theory and the recognition and development of the haptic sense. We believe that the most essential and memorable sense of three-dimensionality originates in the body experience and that this sense may constitute a basis for understanding spatial feeling in our experience of buildings.

In the latter half of the book we discuss the relationship between the personal and public implications of body-image theory, review the theme of body movement, and proceed to a more specific vocabulary of architectural forms and their relationships. These chapters are meant to be helpful in tying architectural examples to the substance of our earlier theoretical description, a task which we attempt more explicitly in an analysis of several sites in the final chapter.

One of the premises inherited from the last century is that the mind and memory are somehow at odds with the body. We, however, make a continuing point of the connection between memory and body experiences. We believe that our relation to up and down or in and out, to front, to back, to boundaries and edges shares space in our memories with more purely visual and conceptual matter. The experience of our bodies, of what we touch and smell, of how well we are "centered," as dancers say, is not locked into the immediate present but can be recollected through time. The importance of memory as a part of our existence in the environment has frequently been denied in this century and by some is even now rather embarrassedly characterized as "nostalgia" and dismissed again. We view it as an extension of experience, certainly not as a negation of it.

So here we are, in a world increasingly full of uncaring, unmemorable, even hostile environments, at the beginning of an optimistic book: we will look back at places where human bodies with memories have been able successfully to dwell, and forward to the knowing provision of more and more places with a special sense of Place.

KB and CWM

New Haven, Connecticut
April 1977

Acknowledgments

Perhaps the greatest difficulty in preparing this book was the translation of knowledge based on three dimensional or spatial experience into information that the reader might utilize in the study of architecture. We would like especially to thank Nona Bloomer for reading, criticizing, and questioning the meanings of our discourse in its early stages of development and for making the many hours of work a more joyful experience.

We are also deeply indebted to Robert Yudell for his contribution on body movement. His insights on architecture, dance, and teaching have animated our thoughts both in the classroom and in the writing of this book.

The dependence of designers on designers is traditional, but for Tina Beebe to have voluntarily worked on the book in its experimental stages was extraordinary, and we would like to express our gratitude for that and for the delight her final design gives us.

Whenever we needed solid scholarly advice we instinctively turned to Jeffrey Limerick, to whom we are grateful for criticism, the analysis of the Winslow House, and the tracing and selection of illustrations.

We were fortunate to have the final transformation of the book take place under the editorship of Judy Metro. She not only repaired bits and pieces we had neglected in the writing, but reconnected the threads of our discourse in imaginative ways, revealing meanings we were still struggling to understand.

We thank Helen Chillman, librarian of the Yale Slide and Photograph Collections, for both providing and helping us find illustrations. We also extend thanks to our colleagues William Hersey, John Kyrk, and Martin Schwartz for their help in completing many of the drawings, and to Marcia Due for her special efforts in taking photographs of Manhattan.

We express gratitude to our colleagues on the faculty of the Yale School of Architecture for pro-

viding a forum of thought for our central thesis along with a good measure of open criticism. And we admit that without the students' unending and energized expressions of doubt, curiosity, and humor, we certainly would not have been inspired to write this book.

1 Beyond the Body Boundary

At the very beginning of our individual lives we measure and order the world out from our own bodies: the world opens up in front of us and closes behind. Front thus becomes quite different from back, and we give an attention to our fronts, as we face the world, which is quite different from the care we give to our backs and what lies behind us. We struggle, as soon as we are able, to stand upright, with our heads atop our spines, in a way different from any other creatures in the world, and *up* derives a set of connotations (including moral ones) opposite from *down*. In our minds left and right soon become distinguished from each other in quality as well as in direction, as words like "sinister" and "dextrous" record.

All these qualitative distinctions, based on our own awareness of ourselves, are implicitly called into question once we start our formal education and learn a new system, the Cartesian, in which the spatial relationship of things can seem much more precise, even as the quality of location is safely ignored. This system can locate precisely any point along *x, y,* and *z* axes even as it renders all the possible points somehow the same. (1) Our cities are stacked up in layers which bear testimony to the skills of the surveyor and the engineer in manipulating precise Cartesian coordinates, but they exhibit no connection with the body-centered, value-charged sense of space we started with (though there is some experiential bonus for getting up to the top). (2)

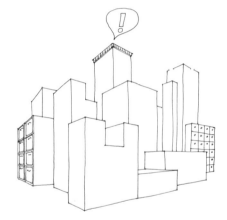

One tell-tale sign remains, in modern America, of a world based not on a Cartesian abstraction, but on our sense of ourselves extended beyond the boundaries of our bodies to the world around: that is the single-family house, free-standing like ourselves, with a face and a back, a hearth (like a heart) and a chimney, an attic full of recollections of *up*, and a basement harboring implications of *down*. In children's drawings of houses (sometimes even in countries where the houses do not look like ours) there is generally a door like a mouth, windows

1
A morally neutral point on a Cartesian grid
2
A surveyor's Cartesian city

like eyes, and a roof like a forehead, with symmetrical enhancements in front. (3) In real houses, however modest, details of craftsmanship and signs and artifacts are developed at critical places to tell a story about the interior of the house, just as the expressions of the human face speak of inner feelings. This house facade is not, note, a billboard, a simple sign, but rather the complex intimation of much more within. Just as a certain roundness in the rough surface of a geode speaks to the explorer (through his memory of other geodes) of the crystalline splendors inside, the house front speaks to us about what lies behind it, and what it might be like to be inside.

The most important place on the house facade is the front door, to which, almost always, there is a special stepping up. On larger houses the entrance might be under a protective roofed porch, or below a fanlight or a dormer window projecting from the attic, all of which draw connotations of upness to the passage in. (4) The rear, meanwhile, is not at all like the front. It is unlikely that symmetry will have been sought after, or any formal array of windows or doors. The attention, with all the expected anal implications, is to service, trash removal, and privacy.

Inside, the areas of special importance receive special attention. The fireplace, for instance, framing the hearth (which qualifies still as the heart of the house), is honored even now, although the heat may be coming from a furnace located in the basement or even in a closet. A favorite painting

3
A child's clear understanding of a house
4
The good connotations of "up" top the act of going in

2

might go over a mantel on which especially prized objects are placed, and the family's best rug and fanciest furniture are generally nearby. (5) The formal attention to detail is likely to be richer here than anywhere else in or on the house, except perhaps the front door, which opens the way to all this.

In the places away from the hearth, especially above (in the attic) and below (in the basement), lie the domains of fantasy. Vivid descriptions of the significance of these realms are developed in Gaston Bachelard's *The Poetics of Space,* where he explores the parallels between attics and the mind and the superego.[1] The sheds and gables and lanterns which enclose them are more than utilitarian: they top off the house and mediate with the sky. The basement, Bachelard suggests, is the opposite, with implications of the dark id. Other boundaries of the house, too, are departure points for fantasy: the children in C. S. Lewis's *Chronicles of Narnia* enter that world through the back of a wardrobe, and of course Lewis Carroll's Alice climbs through a looking glass.

Outside lies the strangely ubiquitous phenomenon of the American open lawn.[2] Not walled as the gardens of Europe or the Near East, the lawn sets off the house by well-understood prearrangement, giving some measure of the house's stature and autonomy, at times even calling attention to its existence. (6) The lawn in some ways recalls the personal envelope of space that we usually try to maintain around our bodies, and of which any

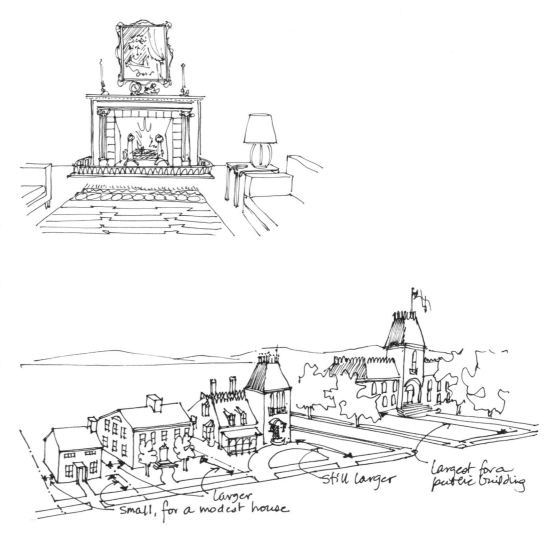

5
Family treasures grace the heart of the house

6
In the United States dimensions of setback often signal the importance of the building

3

violation or infringement is acutely sensed.[3]

The free-standing American house, with its strong assertion of a separate identity, is easier to understand as a miniature palace than simply as a unit of inhabitation. We miniaturize all the time; we endow houses, for instance, with aspects of a larger or more public realm, and talk about the house as a city, with both public and private domains, even as we talk about the city as a house, to try to make clearer to ourselves its representational as well as its business functions. We project ourselves into models and see a dollhouse not only as a focus for a child's dream to be in charge, later, of a full-sized house, but also for an adult's desire to clarify his relationship with his world. The concept of treasury, sometimes shared by a whole nation, as at the Athenian Treasury at Delphi or the Ise Shrines in Japan, remains intact in miniature. A chest or even an object upon a table may gain importance by recalling the columns and arches and even the roof of a house or a palace. (7)

In modern cities throughout the world our sense of orientation, knowing where and who we are, is damagingly compromised. Offices, apartments, and stores are piled together in ways which owe more to filing-cabinet systems or the price of land than to a concern for human existence or experience. In this tangle the American single-family house maintains a curious power over us in spite of its well-publicized inefficiencies of land use and energy consumption. Its power, surely, comes from its being the one piece of the world around us

7
A chest on a table recalls a house

which still speaks directly of our bodies as the center and the measure of that world.

Yet at its beginnings all architecture derived from this body-centered sense of space and place. Mircea Eliade in many of his works, especially *The Myth of the Eternal Return,* describes how peoples perform ritual acts and make buildings in a manner which very carefully emulates, and gains its power, from the primordial acts and constructions of a founding hero.[4] Columns were surely celebrations of the special human upright stance even before they were pressed into service to hold up roofs over human bodies. Walls had been invented to describe human territoriality (to stiffen a boundary just beyond the body itself) even before they were joined into whole systems to make rooms and buildings. And roofs overhead, however urgent the requirement that they keep out the rain, served also to crown a building, like the human head. Architecture, then, developed simply from columns, walls, and roofs which were regarded as talismans. Qualities invested by humankind into those columns, walls, and roofs gave meaning to the built world.

People at first had found a suitable boundary outside their own in caves which kept out rain and helped contain body heat (later the heat of fire as well). In all probability they also extended the image of mother and womb to residence within the womb of the earth mother. (8)

At a later time humankind would more daringly seek shelter in the light and would build a wall around a space open to the sky. José Ortega y Gasset links this move with the development of Mediterranean civilization itself:

[The] Graeco-Roman *decides to separate himself from the fields, from "nature," from the geo-botanic cosmos. How is this possible? How can man withdraw himself from the fields? Where will he go, since the earth is one huge, unbounded field? Quite simple: he will mark off a portion of this field by means of walls, which set up an amorphous, limitless space. Here you have the public square. It is not, like the house, an "interior" shut in from above, as are the caves which exist in the fields. The square, thanks to the walls which enclose it, is a portion of the countryside which turns its back on the rest, eliminates the rest and sets up in opposition to it. This lesser, rebellious field, which secedes from the limitless one, and keeps to itself, is a space* sui generis, *of the most novel kind, in which man frees himself from the community of the plant and the animal, leaves them outside, and creates an enclosure apart which is purely human, a civil space. Hence Socrates, the great townsman, quintessence of the spirit of the* polis, *can say: 'I have nothing to do with the trees of the field, I have to do only with the man of the city.'*[5]

So the walls followed the development of the city and gave it form. (9)

Seeking to memorialize the masculine part of the creative act as well, perhaps, as to find a way to hold up a roof which would not interrupt the free passage of people or of breezes, mankind invented the column. Tree trunks may have been the first columns, followed by shafts of stone, standing

8
The cave was the womb of the earth mother

9
Walls set apart a public square, which dares open to the sky

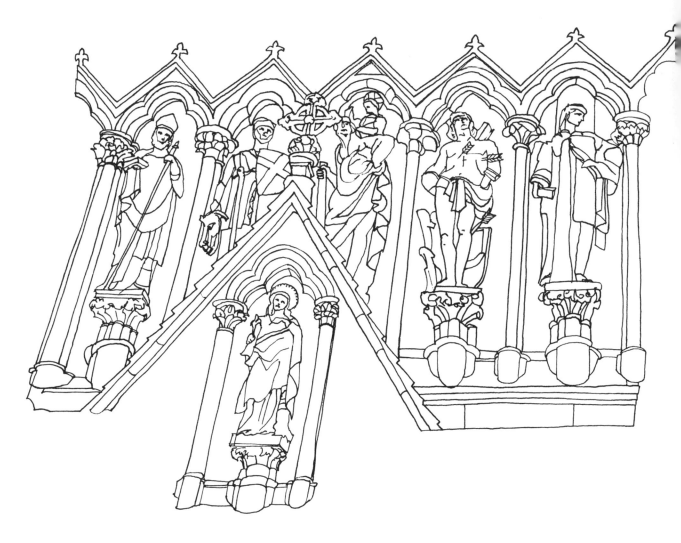

10
Four columns and a roof create an aedicula, a shelter and a place suitable for renewing virility

11
Medieval saints found similar aedicular homes

alone as monuments or in concert as support. Four columns together holding up a roof formed a ceremonial canopy with evident creative or regenerative powers. Under these canopies, from very early times, aging Egyptian pharaohs underwent the *heb-sed* ceremony to extend their virility and postpone the day when their sons would usurp their power. (10) The houses of common men might adopt the same form, and millennia later, medieval saints found homes in such symbolic dwellings along cathedral walls. (11) These places came to be called aediculas.[6]

A row of columns could form a front porch of unusual power. In early Greek cities it was reserved for the head man and used by him when he was dispensing justice. (12) Some centuries later, by the time an extensive set of other-worldly powers and connections had been assigned to the ruler and/or deity, his position in the porch was moved (upward, of course) to a window of appearances suitable for personal occupancy or for a surrogate in marble. (13) The triangular end of a gable roof (the pediment) above the columns, had also been from earliest times a sign for power. It marked the house of the head man, and apparently, like the columns, was reserved for his important appearances as well as for other functions of civic urgency.

In other Mediterranean cultures the arch and dome were favored. The forms were endowed with celestial significance (domus is the word for house, as well as for the dome of heaven), sometimes painted blue inside with stars, and always crown-

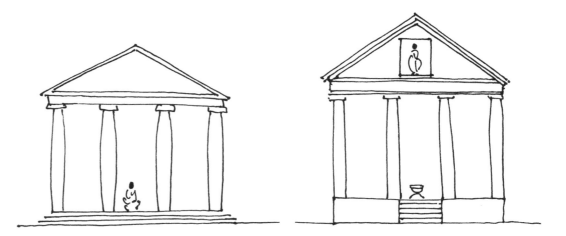

12
There was special symbolic power in the columnar porch, reserved in ancient Greece for the city's chief

13
More deified later rulers migrated upward to a window of appearances

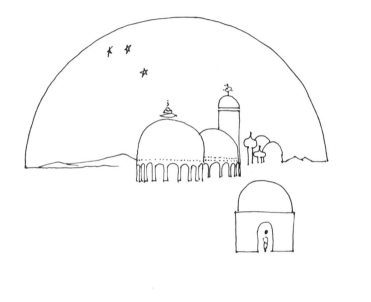

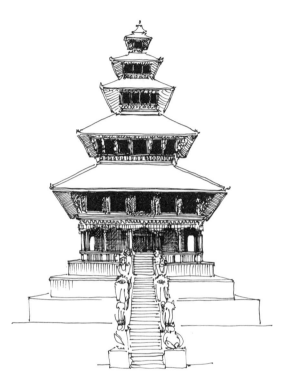

14
Farther east, a dome might crown the building

15
Still farther east, a concentric roof created a central place

16
And it could have its importance enhanced by multiplication

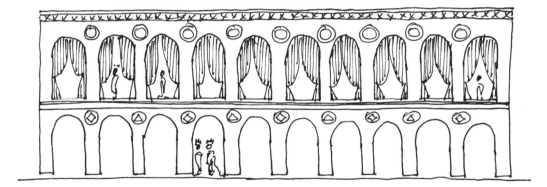

ing the building. (14) Farther east, in China and Japan, the roof typically sloped down on all sides, which pinpointed its centrality. (15) It was given expressive nuance by varying the flare of the eaves and intensified importance by multiplication, resulting in pagodas with three or five or even seven or nine superimposed roofs. (16)

In the countries which employed domes and arches, columns forming an arcade were generally regarded as the domain of royalty, and curtains (perhaps recalling the tents of nomadic conquerors) reinforced the royal image. (17) By Roman times the column had often fused into a wall, but it was used still to suggest potency in, for example, a triumphal arch through which a victorious general might parade. (18) Again, the column might find itself extended into a tower, perhaps with a dome on top, and possibly even

17
Arcades formed the royal domain

18
An arch and columns were both present for a triumphal arch

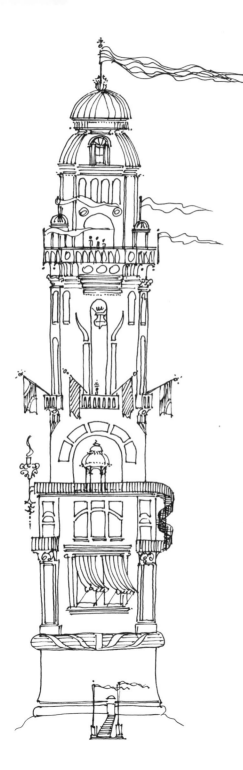

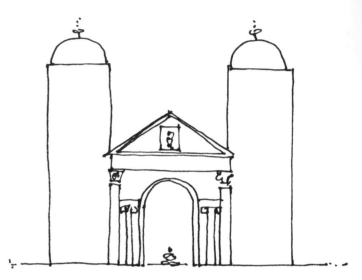

19
The column could burgeon into a tower

20
And the whole triumphal apparatus
could be combined into a portal

with a device or banner on top of that. (19) And the whole triumphal apparatus — porch, arch, arcade, tympanum, columns, tower, dome, and banner — might be combined into a portal, which could function as the west front (the face) for a building whose plan might recall the body of Christ, or could be detached from a building and moved to serve as the gate to a whole city or as a place of sufficient importance for Solomon himself to occupy and from which justice could be dispensed. (20–22)

The house of God shaped after the body of Christ was splendidly suited, as it turned out, to processions of celebrants. Moving the length of the nave toward the sanctuary, their upright bodies reflected, as they had caused to exist, the soaring spaces above them, and the gabled roof visible from the outside further extended the verticality of

21
Behind the portal might lie the body of Christ

22
Or a whole city, whose gate might serve, as Solomon's did, as a seat of judgment

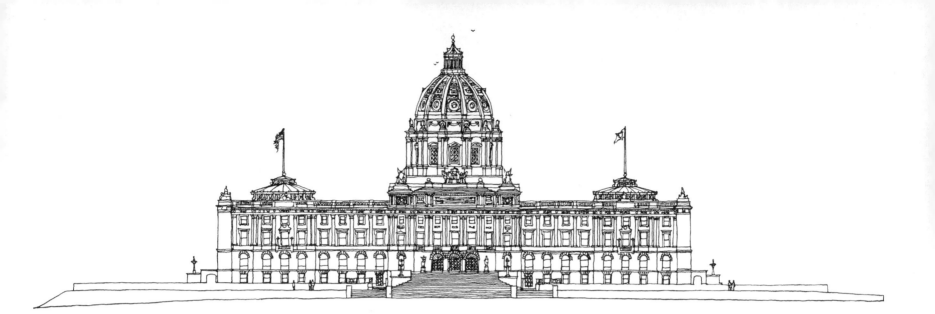

the upright bodies. (23) A latter-day serendipity can even be said to have existed in the state capitols in the United States, almost always centered on a high dome, flanked more or less symmetrically by the two houses of the legislature in the explicit image of the body politic, (24) although in most states this image has been buried under an inundation of executive filing cabinets.

Some millennia after the Greeks and Romans, we find Louis XIV announcing "L'état c'est moi," and his palace echoed the announcement. The king's bed lay at the center of his palace at Versailles; roads from Paris and a host of other places converged on that spot, (25) and from it a web of garden allées extended, locking nature (by implication) in the proud imperial grasp. The accom-

23 (below)
Upright celebrants move under a gable roof

24 (above)
Capitols of the United States present an explicit image of the body politic

25 (opposite)
All roads lead to the king's bed at Versailles

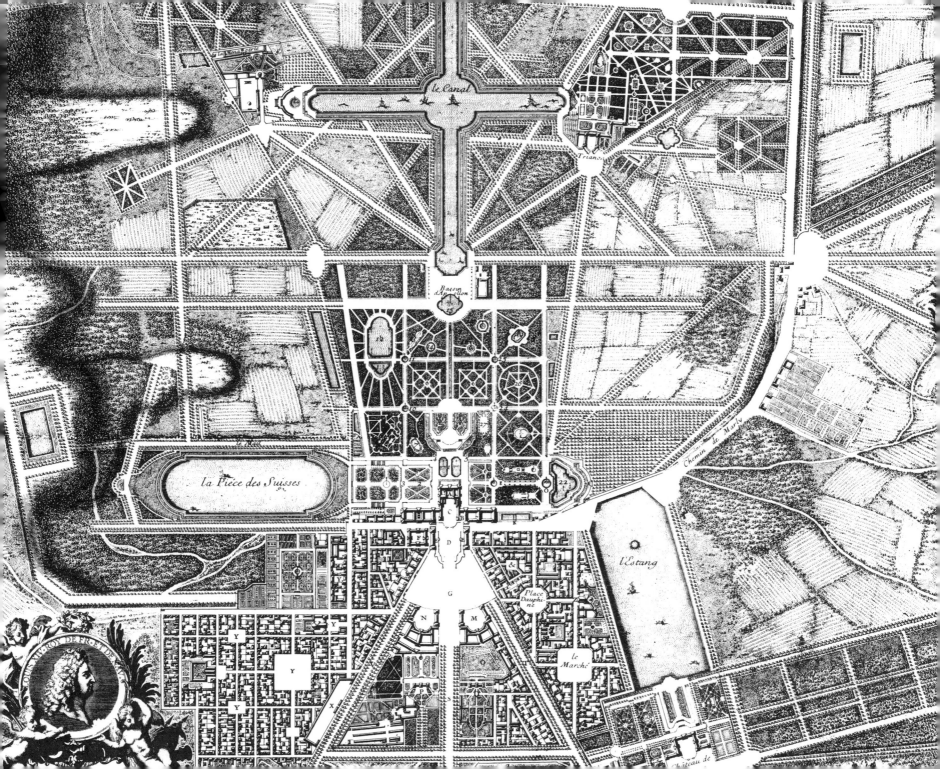

la Menagerie

le Canal

Trianon

Bassin d'Apollon

Chemin de Marly

la Piéce des Suisses

l'Estang

Place Dauphine

le Marché

C

D

E

F

G

N

M

Y

Y

Y

X

S

LOUIS XIIII ROY DE FR. ET DE NAV.

3

22

modation in this one palace of the entire French aristocracy as well as of the complex bureaucracy of the nation's capital required severe modification of the ancient models. For all its intimations of unity and centrality, the single visible roof, for example, which covered the pharaoh for the *heb-sed,* or the Greek chief in his megaron porch, or the triune God in the medieval cathedral, simply would not extend over such an expanse even if a single capstone had been desired. In this palace the wall pierced by carefully regulated openings becomes all-important. Columns are recollected, and included as a part of the wall (as they had been in the triumphal arch), but they appear in their free-standing form only as the carefully regimented trees of the forest, extending the body of the king (comparable to the body politic) into the landscape in an explicit geometry more extensive than the Western world had ever before experienced. (26)

Louis XIV is probably even more important to our story than he so immodestly thought he was to history. With him the idea of a complex and specialized building began to emerge.

26
*In the great palace-city columns begin
to fuse into a wall*

2 The Mechanization of Architecture

Since Louis XIV and into our own time, architectural themes and designs have come to be organized around special functions. Office buildings and apartment and medical "complexes" are built and accepted simply because they serve a specific purpose, independent of whatever homage they may pay to history and the human condition. The roots for such an acceptance go back to the years of the Enlightenment.

A specialized architecture which ignored and excluded the more general function of extending the human self and order onto a portion of the earth into an "ethnic domain"[7] had been academically sanctioned as early as the seventeenth century, when Western Europe began to industrialize. At that time the human and divine themes perpetuated by the aristocracy and church were challenged by the engineers, militarists, and industrialists whose influence was rapidly expanding.

The transition from the presence of the body as a "divine" organizing principle in architecture to a more mechanical organization gained momentum from Galileo's arguments in favor of mathematical measurement and experiment as the criteria for physical truth. Telescopic observation and the mathematical analysis of freely falling bodies could describe for Galileo a world which obeyed mechanical laws, and the human body as well as the starry skies belonged to that world. Before Galileo, it was natural to imagine an architecture which celebrated the properties of the human body, and easier to believe that this body was possessed by a sacred authority. But if, instead, the human body was thought to obey mechanical laws, should not the architecture which served it also obey mechanical laws? A search for new laws with which to govern all physical form was institutionalized by the founding of national academies of science and learning throughout Europe.

The Royal Academy of Architecture (established in

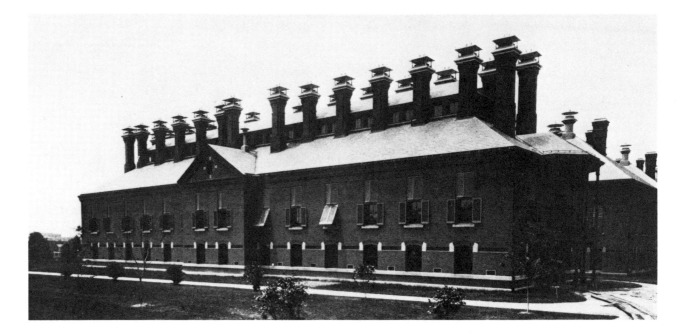

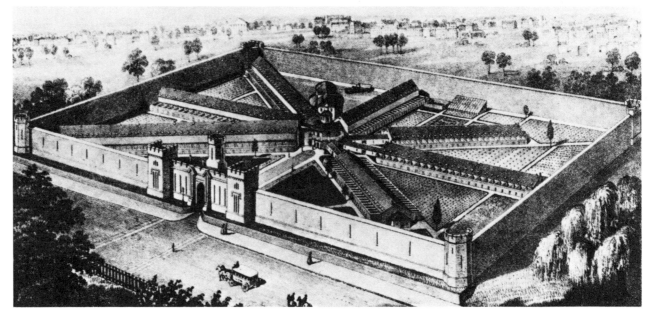

27
*Then came specialized buildings shaped
not after the human body, but after
a machine metaphor, like the isolating
ward at Johns Hopkins Hospital
(1885)*

28
*The Haviland Eastern Penitentiary in
Philadelphia (1821–36) is a building
designed for the efficient surveillance of
prisoners*

Paris by Colbert in 1671), as well as the other royal academies of the period, was founded on the premise that a new set of norms, opposed to the archaic ones, was needed: norms for the fabrication of objects ranging from poems to bridges, from porticoes to astronomical instruments and from bastions to tapestries. These were "rules" to be sought after in the objective observation of nature, and not, as they had been in the past, imposed by the archaic forms of authority. . . . Whereas the archaic conceptual framework had referred to a set of design decisions warranted by divine law, the modern one was to be warranted by the need to maximize utility and to minimize cost.[8]

Inevitably debates arose as to whether a building was "beautiful" because of its ornament and proportions, or because of other more "functional" criteria. Engineers argued that proportions should indicate the mechanical properties of the building, and thus the thickness of a visible beam should demonstrate the weight it carried; doctors proposed that their hospitals be shaped as ventilators for the removal of germs from the air within; and prison officials asked that their buildings be designed for the efficient surveillance of prisoners. (27, 28) Military engineers seized for their own the right to plan urban fortifications, whereas in earlier times artists such as Leonardo and Michelangelo had undertaken the construction of these civic buttresses. (29)

These different and often conflicting interests were to be intensified by the growth of scientific studies during the Enlightenment. At this time,

for example, the study of physics became separated from the study of philosophy within the academies. Eventually different kinds of national schools were founded, dedicated to more specialized professional and applied studies. Engineering schools emerged as independent institutions around 1740 in France and 1754 in Germany, while medical academies asserted their independence from scientific societies throughout the eighteenth century. Like industry itself, this specialization created a complex division of purposeful labor which was to recognize and generate alternate ways of defining architecture. Architecture had benefited from an embodied and memorable legacy when it was centered around a sacred model, but with the Enlightenment a great many new models evolved; palaces and churches had to compete for architectural eminence with a range of secular building types.

Between 1750 and 1758, within the same academic climate that led to the founding of schools of art, engineering, and applied science, the German philosopher Alexander Baumgarten wrote two volumes called *Aesthetika* in which he attempted to establish aesthetics as a scientific study.[9] His was the first systematic effort to employ rational principles and scientific rules for the treatment of the beautiful, and to elevate the study of that which depends on feelings and the sense of beauty to the status of a science with an independent body of knowledge. By recognizing that feelings dealt with sensitive knowing as com-

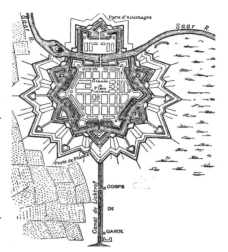

29
Toward the end of the seventeenth century construction of fortifications was undertaken by military engineers; Vauban designed Saarlouis in 1680

17

30
A good Beaux Arts plan is like a well-muscled body; walls thicken to perform feats of support

pared to rational knowing, Baumgarten proposed that sensing the beautiful was *real* knowledge. (His conclusions, however, had the effect of taking with his left hand what he had given with his right, for he still emphasized the difference between the nonrational knowledge derived from the senses and the pure knowledge derived rationally from logic, and he continued to declare that while sensible knowledge was also real knowledge, it was nevertheless inferior to the clear and distinct knowledge developed logically by the mind. Thus the science of aesthetics was dubbed by its founder to be a science of lower knowledge; art, it was implied, was inferior to science.)

While the Royal Academy of Architecture in France emphasized the scientific approach to architecture, the Ecole des Beaux-Arts, founded shortly after the French Revolution, treated architecture as an art. It started with a concern for human experience, personal identity, and a carefully developed sense of compositional order and beauty. These qualities defied (as they still do) precise quantification, though the presence of sensual delights can be noted in magnificent existing buildings. What resulted in the ensuing years, not surprisingly, was a sophisticated evolution of techniques to elaborate a model which included some (but not all) aspects of building. The main concerns were with sections, elevations, and especially plans in which walls were the expressive medium. (30) On architectural drawings these were thickened (and filled in with carefully ground

ink) to correspond to sensed structural necessity (just as the well-developed musculature of limbs and torso may express the grandeur, proportion, and fitness of the human body).

The idiom of this partial body metaphor in Chinese ink and watercolor could be based on the five kinds of columns known to the ancients, or on the medieval modes, or later even on the Spanish or Egyptian modes. (31–33) Regardless of whether these archaic symbols became gradually of di-

31 (top left)
The idiom might be classical

32 (top right)
Or Spanish

33 (bottom)
Or even something especially exotic, such as Egyptian

19

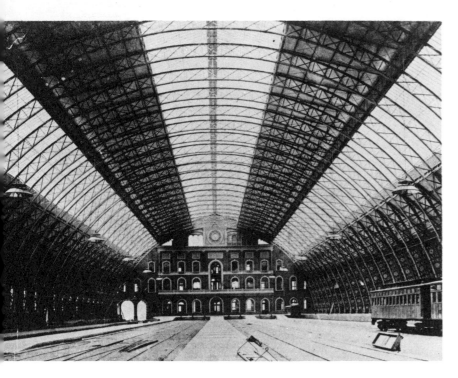

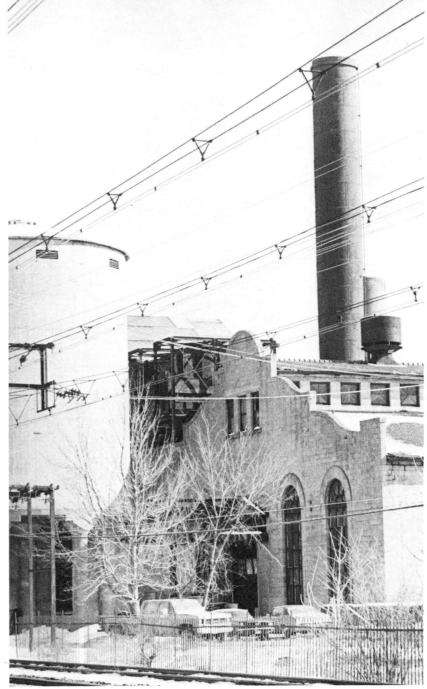

34, 35
But a Beaux Arts building might
demonstrate a rather hermaphroditic or-
ganization; the first Grand Central
Station, New York (1869–71) and the
Cos Cob Power Plant, Connecticut
(1906) combine both classical and
mechanical parts

minishing interest to the world at large, or to the people responsible for equipping complex functional environments, a schism in architectural thought was to develop.

The trouble was that this splendid translation of human existence into architectural form cared little for what human occupants did or accomplished as they went about their business, and such commonplaces as the delivery of comforting heat received scant attention from the architects trained at the Ecole. Moreover the excitements of a developing technology, the delicacy of spun cables bridging great distances, or the power of rushing trains, were given a separate status from "architecture," so that a rather hermaphroditic organization might appear in a monumental setting such as railroad station or a power plant. (34, 35) In the former case, for example, an enormous futuristic span could be constructed in the rear to house the trains while the stationhouse itself would be romantic, reminiscent of earlier times, and more celebrative of the human body. Certainly both halves of these schismatic structures were appealing in their homage to different-sized "occupants." How indeed could an academic concern with human sensuality and memory cope with a technological point of view during those years in which nature was being harnessed with such apparent success?

A fundamental distinction is evident between an attitude which treats architecture as an applied science and one which treats it as a more holistic art. The former, in its pure form, does not explicitly carry a notion of human identity independent of an efficiently operating function, but instead attempts to predicate identity on the function itself. The basic purpose of developing schools of engineering was to establish the precise rules governing the objective performance of physical operations, not to consider the emotional experience of human beings. (Unfortunately, by these standards, a specific work of architecture from the past could be declared generally inferior because of its awkward and less efficient technical resolution, even if it gave to its inhabitants a superior feeling of joy and satisfaction.)

The academic difference between engineering and art schools was to become institutionalized by the different ways in which buildings were to be measured (and by whom or what). The struggle to determine new laws of measurement for every aspect of architecture was thus coincident with the founding of modern architectural thought. As the authority of the sacred themes became either less acceptable or less comprehensible, the need to debate the basis for these new norms of measurement intensified.

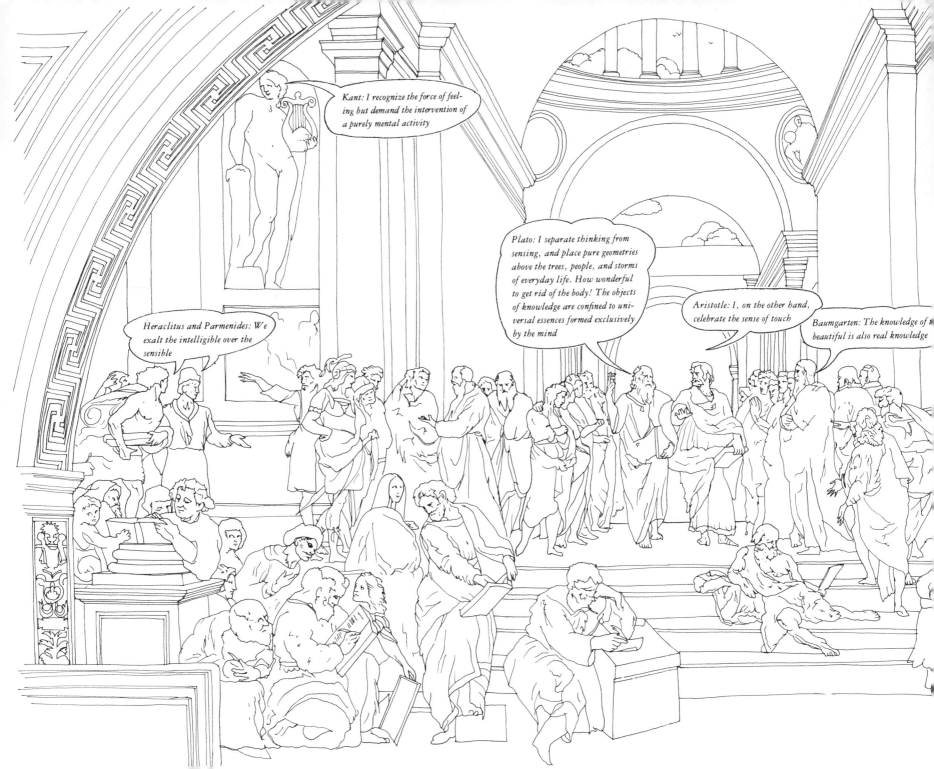

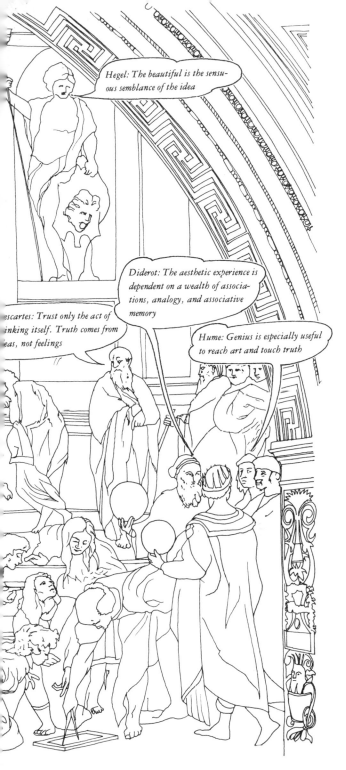

3 The Sense of Beauty

From the beginning of academe in ancient Greece there has been inquiry into the laws and priorities which govern our sense of beauty. (36) This inquiry necessarily included attempts to describe the role of the body and its sensory apparatus. (The word "aesthetics" comes from the Greek *aesthetikos,* meaning "of sense perception.")

After the seventeenth century the aesthetic debates and theories about the way we sense beauty were to influence, and indeed powerfully to prejudice, our understanding of how we experience architecture. Descartes was so skeptical about the reliability of the senses that he trusted only the act of thinking itself. Cartesian "rationalism" called for the assignment of objective meanings to things, and these meanings were to be deduced, not sensed. (37) His followers were to declare that objective truth radiates from an internal world of ideas, not feelings. His detractors, on the other hand, noted that deduction does not account for many of the spontaneous manifestations of

36
Philosophers engaged in disputations about the body and the mind

23

"genius" and imagination found in the great works of art and architecture. By regarding architectural problems and challenges as the province of deduction rather than feeling, the bodily senses, which were not considered to be prime instruments of thought, would acquire an inferior status (as Baumgarten later suggested). (38)

However there were voices throughout the Enlightenment which argued that feelings, independent of reason, were able to reveal a measure of truth. A reminder of those arguments may serve our understanding of the impact the concept of beauty was to have on modern theories of sense perception.

The Earl of Shaftesbury, an early influence on English aesthetics, did not attempt, like Baumgarten, to systematize our understanding of beauty and commented that "the most ingenious way of becoming foolish is by a system."[10] (39) The French philosopher and art critic Diderot in the mid-eighteenth century spoke of the aesthetic experience as being dependent on a wealth of associations. A great poet could establish relationships through analogy and associative memory which, powered by his imagination, were not the product of the classical form of exact reasoning. In England Hume actually challenged reason directly. Feeling does not have to justify itself, he said; in matters of beauty, reason should surrender its overextended authority to the imagination. (40) Hume proposed that feelings might express a conformity between an object and an organ of the mind inde-

37
Descartes: One must deduce the meaning of buildings, not sense them

38
Baumgarten: Sensible knowledge is of course inferior to knowledge developed by the mind alone

pendent of a reasoning process, and thus "genius" might be seen as being particularly powerful, creative, spontaneous, and intuitive in sensing truth.

Edmund Burke lent the argument a physiological tone in his *Philosophical Enquiry into the Origin of Our Ideas of the Sublime and Beautiful* which appeared in 1757, by suggesting that "beauty acts by relaxing the solids of the whole system" and that in visual beauty the feelings generated by smoothness result from relaxing muscles, while "bodies which are rough and angular rouse and vellicate the organs of feeling."[11] (41) The bodily senses and the sense of beauty are closely allied in this proposition.

However, Immanuel Kant at the end of the century challenged the authority of pure feelings

39 (top left)
Earl of Shaftesbury: "The most ingenious way of becoming foolish is by a system"

40 (bottom)
Hume: Reason should surrender its over-extended authority to the imagination

41 (top right)
Burke: "Beauty acts by relaxing the solids of the whole system. . . . Bodies which are rough and angular rouse and vellicate the organs of feeling"

purely sensuous particular thing and its gravity, hardness, softness, and material resistance. A work of art, is, however, not merely a sensuous thing, but Spirit manifested through a sensuous medium. As little can we exercise our sense of taste *on a work of art as such, because taste is unable to leave the object in its free independence, but is concerned with it in a wholly active way, resolves it, in fact, and consumes it. . . . As for the sense of* smell, *it is just as little able to become an organ of artistic enjoyment. . . .* [13]

Sight and hearing, on the other hand, were "ideal" senses because they did not alter or consume their objects.

The ear receives also in an ideal way, just as the eye [receives] shape and colour, and suffers thereby what is ideal or not external in the object to appeal to what is spiritual or non-corporeal. [14]

For Hegel, the work of art fundamentally addressed itself to the "mind," and its function was "just this and only this, namely to bring before the grasp of the senses truth, as it is in the world of spirit." The highest expression of truth, however, was not through art, but through the abstract thought of philosophy. Art, Hegel therefore concluded, was now "a thing of the past." It is no wonder that the aesthetics of Hegel has been referred to as a "funeral oration." [15]

If art was thought to be superceded by abstract thought so was the body being bound and gagged by the supposition that the organs of aesthetic pleasure were limited to sight and hearing. (43)

by acknowledging that although there were forces of feeling, our response to those forces would not give us pleasure unless we made a *mental judgment* of them. [12] The effect was to intellectualize feeling by requiring the intervention of a judgmental activity. (42)

In the early nineteenth century Hegel, the last of the great German system-builders in philosophy, emphasized, more than any of his predecessors, the mental aspect of art. He defined the beautiful as "the sensuous semblance of the Idea" and, while allowing that art is also "art for the *senses,*" Hegel limited those senses which were organs of aesthetic pleasure to sight and hearing, excluding touch, taste, and smell.

By the sense of touch *the individual merely comes as an individual endowed with sense, into contact with the*

42
Kant: Recognizing the force of feeling but demanding the intervention of a purely mental activity

43
Hegel: Limiting the organs of aesthetic pleasure to sight and hearing

Empathy

There were, however, some noteworthy efforts in nineteenth-century aesthetics to incorporate the body more directly into the experience of objects. The philosopher Robert Vischer, who coined in 1872 the word "empathy" (*Einfühlung*), spoke of it as being a feeling rather than a process of formal thought.[16] He sensed an almost mystic quality in empathy and spoke of a person forming an emotional union with an external object. Observing that feelings may be aroused by experiencing totally abstract objects (as well as storms, sunsets, and trees), he surmised that we may empathize with objects by projecting our personal emotions into them. (44) (For our purpose the objects would be architectural settings with or without explicit functional or symbolic content.) He suggested in this way that the feelings of the artist while making a work of art could become the content of the work of art. This was an extraordinary thought, for in the context of architecture it implied that feelings of the inner self might be projected to the walls, doorways, and domes of a building. Theodor Lipps, in his *Raumaesthetik* (*Aesthetics of Space*, 1893–97), was to characterize empathy as the objective enjoyment of self; for him positive empathy (beauty) is where the self is encountered in the object, and negative empathy (ugliness) is where the self is repelled.[17]

Some early twentieth-century exponents of empathy tried to find specific formal identities between the shape and activity of the object of empathy and the body-reaction of the perceiver.

You see a mountain on the horizon. . . . you actually raise your eyes and strain your head and neck upwards, and this fills you with a feeling of an effort of exaltation. . . . You always, in contemplating objects, especially systems of lines and shapes, experience bodily tensions and impulses relative to the forms you apprehend, the rising and sinking, rushing, colliding, reciprocal checking, etc. of shapes.

Looking at this jar one has a specific sense of a whole. To begin with, the feet press on the ground while the eyes fix the base of the jar. Then one accompanies the lift up, so to speak, of the body of the jar by a lift up of one's own body. . . . Meantime the jar's equal sides bring both lungs into equal play.[18]

The historian Geoffrey Scott, in his celebrated *Architecture of Humanism* (1914), made similar references to the body but in phrases which seem much closer to our own experience:

Weight, pressure, and resistance are part of our habitual body experience, and our unconscious mimetic instinct impels us to identify ourselves with apparent weight, pressure, and resistance in the forms we see.

In his discussion on scale and ornament in buildings, Scott went on to say:

In any building three things may be distinguished: the bigness which it actually has [mechanical measurement], the bigness which it appears to have

44
We may empathize with objects by projecting our personal emotions into them

45 *(left)*
The bigness which the building actually has

46 *(right)*
The bigness which it appears to have

47 *(bottom)*
The feeling of bigness which it gives

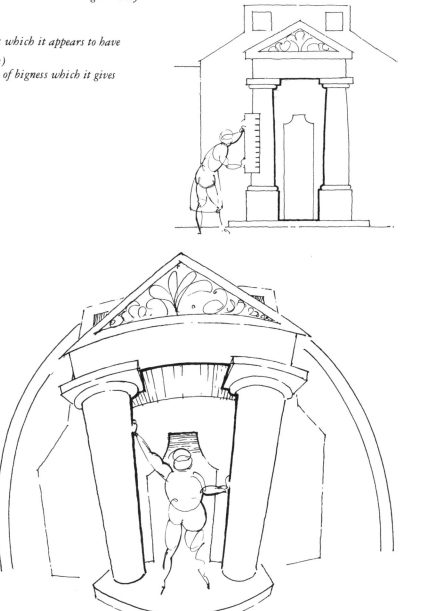

[visual measurement], and the feeling of bigness which it gives [bodily measurement]. The last two have often been confused, but it is the feeling of bigness which alone has aesthetic value. [19]

This prophetic reference to a "distinction" between mechanical, visual, and bodily measures, together with the "confusion" cited between the appearance of a building and the feeling it gives, reveals the profound dilemma inherited by the twentieth century from the debates of the Enlightenment. (45–47) The visual sense had been exalted for so many centuries that other means of sensing objects had come to be regarded as definitely inferior and less important in the formulation of knowledge about objects, including

buildings. (The word "enlightenment" itself echoes the Platonic metaphor of vision, which connects sight with light and truth.)

By the end of the nineteenth century almost all aesthetic problems which dealt with three-dimensional forms were treated automatically as visual problems. In contrast to the apparent loftiness of seeing, the sense of touch had been reduced to a sort of Victorian fingertip activity (better with gloves on) more comparable to measuring with calipers than with the whole body. (Even some sculptors, despite the directness and three-dimensionality of their art, deferred to the visual. The turn-of-the-century sculptor and aesthetician Adolf Hildebrand argued in writing about form in sculpture and architecture that sculpture was a visual art derived from drawing. He preferred to have finished sculptures viewed from a distance rather than intimately.)[20]

It is well to recall that during this time the body had become a barely mentionable appendage to the brain, hardly to be discussed in the drawing room. Legs were called "limbs" and the glimpse of a female ankle might allow an inadequately repressed libido to bound out of control. (48) The body was even less likely to be considered in any rational discussion about architecture, where no argument had successfully competed with the post-Galilean view of the physical body as a machine. Though the human being was seen as possessing a psyche (or a soul), the "physical part" was cast as a subject of mechanical laws. Moreover the word "body" had generally come to denote the physical, nonrational, and nonpsychic (or "mindless") body. The focus on conceptual and mental processes and their contrast with the physical operations of the body had reinforced the belief in the separation of body and mind. (49) In this duality the body was a cumbersome necessity that served the lofty "mind."

48
By the end of the nineteenth century, the body had become a barely mentionable appendage to the brain

49
And it was thought that the function of the body was to support the lofty mind

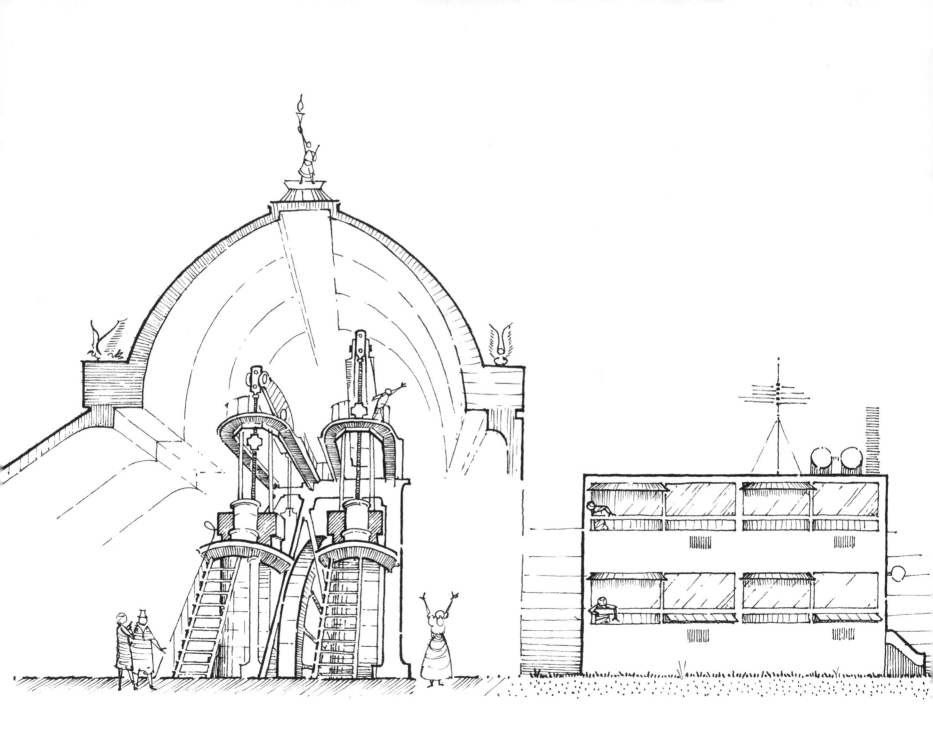

4 Some Twentieth-Century Models of Sense Perception

It must have been especially difficult to imagine one's own body as a machine in the nineteenth century if one took as a model those celebrated in Machinery Hall at the Centennial exhibition in Philadelphia in 1876. Those steamy behemoths were huge and awe-inspiring, but with a kind of dumb charm. They were most unlike the machines for living of the mid-twentieth century, which are smaller and cleverer, somewhere between devious and boring. (50)

In the ranks of architecture the objective disciplines of engineering were continuing to perform predictably with the promise of a better future while the influence of aesthetic theories declined. The study of aesthetics seemed esoteric, unpredictable, and perhaps slightly decadent in its struggle to explain feelings and body reactions without the advantage of precise experimental methods. It was the psychologist who in the early years of this century utilized the method of experiment in the study of sense perception, and in so doing was able to share with the engineer the claim of objectivity.

Beginning about 1910 a new theoretical model emerged from the findings of the Berlin school of Gestalt ("form") psychology. This brilliant group of theorists was able to demonstrate (and in due course to "prove" by experiment) that in fact irrational forces in the act of perceiving reacted on and transformed the object being perceived. Moreover, they were able to recognize certain consistent patterns in the way the majority of healthy adults recognized data during the act of perception. Events in the visual field of perception, for example, were simplified by a phenomenon they called closure (a tendency to reduce a complicated pattern to a more recognizable and simpler pattern). Remarkable in these observations was the revelation that individuals also tend to simplify patterns toward horizontal and vertical rather than skew organizations; toward symmetry rather than asymmetry; and toward basic geometric groups

50
The machines of the nineteenth century were steamy behemoths; their twentieth-century successors are cleverer and smaller

rather than random or less precise ones. For example, a square was shown to be the most memorable and neutral form because of its orientation and regularity. The group appeared to have discovered an inventory of experimentally demonstrable prejudices which governed the human perception of external objects.

The appearance of the Gestalt experiments in *visual* perception was to have an enormous effect on the development of twentieth-century modern movements in architecture. These refreshing trials seemed to be exactly what was needed in the context of the pluralist and conflicting viewpoints that constituted architectural education. Theories could now be developed directly from experimental findings in ways parallel to, and as promising as, the experiments of systematic engineering. It was not surprising that some exponents of a revolutionary architectural theory in the early twenties were to see in Gestalt psychology the foundations for a rational and nonarbitrary explanation of beauty. Moreover, the observation that humans possessed a tendency or a "will" to simplify and order stimuli lent support to those who championed the economics of a new industrialized architecture and who argued that efficient, coherent, and rectilinear geometric forms which individuals seemed to recognize more rapidly were a higher form of architectural expression. This model of perception was subsequently to buttress those notions in design which considered simplicity and the exclusion of decorative ornament a virtue and a moral necessity.

It is difficult to find fault with the accomplishments of the founders of Gestalt psychology, but it is not difficult to question the direct translation of their early experimental findings in two-dimensional *visual* perception into the foundation of a new aesthetic in architecture. As Geoffrey Scott had observed, there is a distinction between the appearance of bigness and the feeling of bigness that a building gives, and only the latter, he added, has to do with aesthetic experience. He seems to have been warning us not to accept a standard of architectural beauty derived from visual criteria alone.

Perhaps the quick acceptance of experimental findings favoring a visual geometric simplicity was symptomatic of an intellectual prejudice within European academies derived from Platonic thought, for it was Plato himself who had exalted the sense of sight above all the other bodily senses and who had sought the purest medium for our knowledge of perfect forms.

The Five Basic Senses

The notion that there are five basic senses seems to have been generally accepted throughout the Enlightenment, although it is important to note that considerable confusion about our sensory machinery arose during the nineteenth century as a consequence of efforts to identify and categorize the various sensory apparatus throughout the body.

The confusion centered around relating individual body organs to the many different sensations that seemed to be perceived. "Roughly from 1830 to 1930, investigators tried to make an exhaustive inventory of the sensations. . . . Aristotle's sense of touch, the fifth sense, did not seem to be unitary on careful examination. For one thing it had no organ like the eye, ear, nose, or mouth, and the skin did not fit the idea of a sense organ."[21] Thus the classical sense of touch was divided into five sensations: pressure, warmth, cold, pain, and kinesthesis (sensibility to motion). This scrambled inventory of sensations deriving from touch, with its detailed references to stomach aches, prickly pains, and frostbite, could hardly have lent elegance to a study of aesthetics. Fortunately, perhaps, by 1930 the method of investigating the senses by categorizing the many types of sensations throughout the body had become frustrating, excessively complex, and more useful to physiologists than psychologists. Well after the beginnings of the modern movement in architecture the way was set for new strategies for systematizing the senses psychologically.

J. J. Gibson, acting as an environmental psychologist rather than as an investigator of physiological apparatus, has contributed enormously to the literary unscrambling of the sense of touch and has even added another "basic sense" for our consideration. His strategy was to regard the senses as aggressive, seeking mechanisms and not merely as passive sensation receivers.[22] By characterizing the senses as active detecting systems constantly seeking out information from the environment, he was able to produce a new and more compact inventory of the senses. He did this by focusing on the types of environmental information the body dealt with, rather than on the variety of sensory apparatuses and responses of the body.

Like Aristotle, Gibson lists five basic senses, but unlike Aristotle, he defines them as perceptual "systems" capable of obtaining information about objects in the world without the intervention of an intellectual process. While Aristotle lists the senses of sight, sound, smell, taste and touch, Gibson lists the senses as the visual system, the auditory system, the taste–smell system, the basic-orienting system, and the haptic system. Gibson's treatment of the visual and auditory systems is not of particular interest to us here, since these senses have been thoroughly examined in architectural and psychological literature. And it will suffice to say that the combining of taste and smell into a single system is the logical product of Gibson's focus on the type of information received instead of on the physiological details of the receptor (i.e. these two senses are considered as seeking the same information, one by eating solubles, and the other by breathing volatile components of solids). Of greater significance to us are Gibson's *basic - orienting* and *haptic* systems, for these two senses seem to contribute more than the others to our understanding of three-dimensionality, the sine qua non of architectural experience.

Basic-Orienting and Haptic Systems

Basic orientation refers to our postural sense of up and down which, because of its dependence on gravity, establishes our knowledge of the ground plane. A consequence of this postural orientation is our need to symmetrize frontally the stimulus impinging on the senses of sight, sound, touch, and smell. For example, if a hunter senses danger he will turn his head and focus his eyes and ears symmetrically on the source in preparation for an attack or defense. This mobilized orientation involves a total body balance. Gibson's reference to this sense of orientation takes on poignant meaning when it is listed alongside the classical senses, for one cannot escape the feeling that something had been missing all along, or at least suppressed in our conscious thinking about "sense" perception.

The haptic sense is the sense of touch reconsidered to include the entire body rather than merely the instruments of touch, such as the hands. To sense haptically is to experience objects in the environment by actually touching them (by climbing a mountain rather than staring at it). Treated as a perceptual system the haptic incorporates all those sensations (pressure, warmth, cold, pain, and kinesthetics) which previously divided up the sense of touch,[23] and thus it includes all those aspects of sensual detection which involve physical contact both inside and outside the body. For example, if you accidentally swallow a marble you

may haptically sense it as it moves through your body, thus experiencing part of the environment *within* your body. Similarly, you may sense body motion haptically by detecting the movement of joints and muscles through your entire bodyscape. (This property of haptic sensing is called kinesthesia.)

No other sense deals as directly with the three-dimensional world or similarly carries with it the possibility of altering the environment in the process of perceiving it; that is to say, no other sense engages in feeling and doing simultaneously. This action/reaction characteristic of haptic perception separates it from all other forms of sensing which, in comparison, come to seem rather abstract. You see and hear things figuratively and at a distance,

but you touch the actual thing. You can extend haptic perception with an instrument, such as a cane, in which case the "feeling" of an object moves out to the end of the cane; but when you extend sight or sound telescopically or electronically, you continue to see and hear figuratively and at a distance. (51)

The Sense of Dwelling

Gibson's model of perception is an objective one with a clear method of approach. By regrouping the senses around the types of information that individuals seek in their transactions with the physical environment, he has provided us with a rich mechanical model of perception from which

51
We can extend haptic perception with a cane

we might better understand some of the processes that generate experience in architecture. Moreover, by placing the whole body, not just the eyes and ears, at the center of the perceptual experience, he has helped untangle some of the confusion underlying the speculations of European aesthetic thought about our physiological machinery. Of course, constructing a model of perception around environmental information does not take into account the contribution of the body to personal and cultural memories. We do not aggressively seek out architectural form (unless we are lost in the streets of an unfamiliar city or engaged in a survey of architectural details). In a more fundamental sense, we experience satisfaction in architecture by desiring it and dwelling in it, not seeking it. (52, 53) We require a measure of possession and surrounding to feel the impact and the beauty of a building. The feeling of buildings and our sense of dwelling within them are more fundamental to our architectural experience than the information they give us.

52, 53
We experience satisfaction in architecture not by aggressively seeking it, but by dwelling in it

5 Body-Image Theory

Another model of perception which provides powerful clues about our feeling of dwelling is rooted in psychoanalytic thought and has developed as a subject called body-image theory.* All experiences in life, especially experiences of movement and settlement in three-dimensional space, are dependent on the unique form of the ever-present body. It appears that individuals possess an unconscious and changing image of their bodies which is quite separate from what they know objectively and quantifiably about their physicality. If we can

*The term "body-image" is not preferred by all proponents of this theory. Some see in it too much reference to a classical "imaginary" and thus somewhat unreal aspect of experience; phrases such as "body-percept" or "body-schema" may be substituted. For our purpose we mean to accept the body-image as the complete feeling, or three-dimensional Gestalt (sense of form) that an individual carries at any one moment in time, of his spatial intentions, values, and his knowledge of a personal, experienced body. It should be considered a psychical rather than a physical model.

understand more about how we acquire and modify this psychic image of our own bodies, we may possibly obtain a better grasp of the way in which we perceive objects and settings around us.

An example of a psychic body-feeling may be illustrated by an individual's choice of clothing. If a person is depressed and feeling "down" (clinical studies have revealed that many persons do imagine their bodies to have shortened in height after prolonged failure experiences),[24] the feeling may be amended by dressing "up." A hat, uniform, or a new pair of shoes becomes part of the body image and contributes to an individual's sense of size.

The most fundamental organizing principle in the formation of our body image is that *we unconsciously locate our bodies inside a three-dimensional boundary*. (54) This boundary surrounds the entire body and demarcates our "inside" personal space from our "outside" extrapersonal space. It is an unstable boundary subject to events both inside and outside the boundary. It may be regarded as an

54
We unconsciously locate our bodies inside a three-dimensional boundary

extension of the body in the form of an imaginary envelope which modifies our perception of the forces affecting us by magnifying or suppressing the psychological effect of those forces. If there is a particular body zone which is physically weak or vulnerable (such as the back), the shape and texture of the boundary is modified in respect to that particular zone, often by establishing defensive psychological "barriers."

Seymour Fisher has focused on the psychological strength of this primary boundary by studying its resistance (he refers to the boundary as having "barrier" or "penetration" characteristics) and has speculated that strong-barrier persons (strength does not mean inflexibility) are more individuated and more capable of vividly experiencing the environment than weak-barrier persons.[25] Schizophrenics and individuals under the influence of a hallucinogenic drug may dangerously distort their boundary and thus misread the significance of events in the environment; this may lead, of course, to walking out upper-story windows after misjudging the consequences of falling to the ground. The body boundary may be modified by clothing, as mentioned earlier, or by badges, weapons, or any artifact, such as skis, an automobile, or an airplane, that connects directly with the body and is subject to body-reflex actions. This direct extension of the body or a body part that we can push and pull on (or be pushed and pulled by) demonstrates the mechanics of haptic sensing.

Methods for examining the earliest experiences of an individual in order to determine their influence in adulthood were lacking or barely alluded to in the other models of perception that we reviewed in the previous chapter. By focusing on the early years of development, however, body imagists began to appreciate the dynamics and tenacity of memory in spatial perception. The infant does not have a clearly differentiated body boundary but evidently experiences a world in which the body and environment tend to fuse.[26] (55) Long before he reaches any degree of articulate verbal or visual expression the child begins to develop a distinction between an inside and outside world. These two worlds are discovered simultaneously through a process of successful and unsuccessful transactions between his body and the environment in which the child detects and responds to sensations emanating from inside (coenesthesia) as well as from outside the body. The accumulation of these sensations of collision (which occur always in the framework of body posture and motion) develops his consciousness of an individuated self in the world, or an awareness of the difference between "me" and all that stuff "out there." Paul Schilder, who first synthesized psychoanalytic theory and the Gestalt view in 1935, characterized the individual's confrontation with the world outside his body as the simultaneous encounter of an inside world in an outside world, each dependent on the other for its existence and complexity.[27]

It is worth noting that this early experience

55
The infant experiences a fusion of body and the environment

38

marks the establishment of our primordial and hierarchical model of three-dimensionality (the model that children experience when they first gaze up at the stars and wonder where the edge of the universe is). (56) The "form" of this model is developed from the sensing of an inside/outside world primarily by way of the haptic and basic-orienting systems.

The haptically perceived landmarks and voids within the body are the domains perhaps most neglected by the graphic and geometric models of the twentieth century. These landmarks constitute a vast and intricate psychological realm of inner feeling that seems to be much more influential on our comprehension of the environment than we generally recognize in conscious thought.

The heart, with its auditory and rhythmic presence, exemplifies the phenomenon of an internal landmark acquiring a universal spatial meaning in adult life. Expressions such as "the heart of the matter" and the "heartland" refer to the heart as a centerplace. Objectively, of course, we know that the heart is not located in the geometric center of the body and furthermore that it is not the only major organ which is indispensable to life. Yet because we feel its internal presence vividly, it has been given a status at the very center of life and has become a metaphor for love and supreme geographic importance.

Dancers, more conscious of body movements and balance, may locate the abdominal muscles at the center of their body world. However, despite

the varying sites for the location of a corporeal centerplace, it is significant that *a sense of center is indispensable for the ordering of stimuli* and an essential key to the psychic geography of our internal world.

The stomach and mouth also constitute a domain of internal activity. A person knows that his mouth and stomach are connected, and he forms an image of an elaborate and organic internal system. In anger the stomach and mouth become targets of aggression, while in amicable states they become areas of affection. This assignment of targets and goals to the mouth/stomach system may have originated from a basic hunger for food and affection, but eventually this region acquired more general social meanings which became ritualized in combat, entertainment, and courtship. (57)

The brain, an "object" which we precisely name, locate, and populate with legions of activity, is another major landmark in the psychic body scheme. Its material substance, however, is perceived more as a void than a solid (the "hollow" head as the attic of the body). Feelings of emptiness and lightness seem partially to be a psychic reaction to low-pressure zones within, as well as on the body, and to the effect of gravity. Zones of high pressure acquire a psychic impression of weight: when one is standing one "feels" a heavy mass dominantly in the legs; when lying down, the feeling of heaviness moves toward the back, and the abdomen feels empty and lighter. Schilder further developed these observations on the

56
Where is the edge of the universe? — establishing our primordial sense of three dimensionality

57
The importance of the stomach and mouth becomes ritualized in combat, entertainment, and courtship

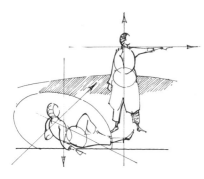

psychic perception of mass within the body by examining how we perceive mass in external objects which are pushing against body parts. He recognized the same tendency to imagine that greater mass was concentrated along zones in the object which touched the body.[28] For example, when we hold a glass of water in our hands, we might imagine its mass to be heavier toward the bottom where it is being held, and lighter toward the top, although we know objectively that the whole mass is homogeneous. Similarly, the foundations of a building "feel" heavier than its airy spires.

In addition to these internal landmarks, we can identify other properties of the bodyscape which are more geometric and linear. Our basic and frontal orienting senses have developed a matrix of *psychophysical* coordinates which constitute our feelings of *up/down, front/back,* and *right/left,* as well as *here-in-the-center*. The right/left coordinate, which psychologically includes the entire body, always remains at right angles to the frontal axis of the face despite body contortion. If, for example, the head is facing toward the left-hand shoulder, the body region traditionally called the front becomes the psychic right side, while the physical back becomes the psychic left side. (The physiological explanation of this comes from the phenomenon of tonic asymmetry: the muscles of the face-side, for example, develop higher tone while the backside muscles show lower tone due to proprioception, the response of muscles in the

body to the orientation of the senses confronting the stimuli). However, the up/down coordinate is not monitored by the direction of the head but is always subject to the direction of gravity.

The psychophysical coordinates may be abstractly described, therefore, as possessing an orthogonal front/back, right/left set of coordinates (centered in the body but guided by the head) which is connected to an equally body-centered but vertically rigid up/down coordinate. (58) The anthropologist Hartley Alexander refers to the seven points described by the psychophysical coordinates as a sacred number representing man's primary projection into the universe as his world frame or world abode.[29] The front/back, right/left coordinates more obviously led to the formation of the four polar coordinates, north, south, east, and west, while the three vertical domains certainly contributed to the existence of the mystical trilogies exemplified in Western culture by heaven, earth, and hell.

Unlike the neutral quantification matrices of mathematics generally deployed in our mapping of the physical environment, the directions of the psychophysical coordinates acquire meanings from early body experiences.

Up/down, our most basic orientation, is the most unstable and yet the most splendid. Its origin as a heroic dimension is as elementary as a child's struggle to stand up and walk and the desire to grow up. Only in the human does the backbone act literally as a column upon which the head rests

rather than from which it hangs. Upward, which in the body image means upward *from the center* of the body (not the whole body moving upward), indicates striving, fantasy, and aloofness. Downward is depressing, but also realistic. Thus we "reach for the sky" while feeling simultaneously the need to have a "firm base on the ground." (Robert Thompson, in an analysis of traditional African architecture,[30] draws a comparison between the expression of the vertical dimension in the gestures and posture of African dancers and European ballerinas: the former are down-beat dancers, pouncing on the earth and darting under objects, while the ballerinas, true to their transcendental culture, leap from the ground and attempt to escape the earth.) (59, 60)

Front is the orientation toward mobility and is imagined perhaps too moralistically, to signify strength and virtue, while back has private and earthy (spatially lower) implications. This psychological debasement of the back illustrates again the distinction between the body image and the physical body. It seems to derive from the fact that most of the sensory apparatus is forward and high up on the face, while the regions of the back have fewer defenses and possess more private and lower functions. We tell people to "back down" when they have gone too far (forward); but when they have a purposeful goal like parking a car we say "back up."

Right- and left-sidedness also acquire meanings derived from experiences of body strength and

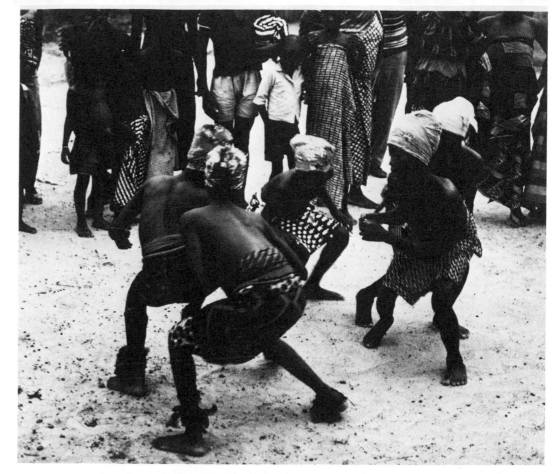

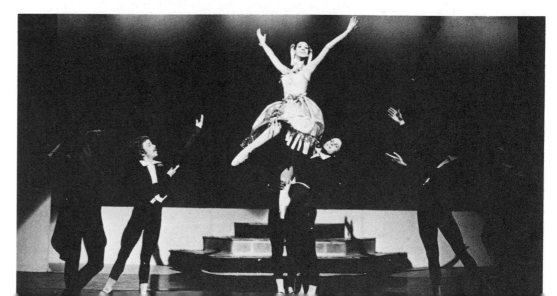

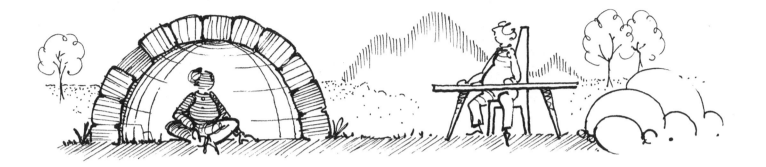

control. Because the right side of the body is generally stronger, it has been accordingly associated with power, dexterity, rationality, and self-assertion,[31] whereas the left side is traditionally associated with sinister purpose, irrationality, and weakness.

By combining the values and feelings that we assign to internal landmarks with the moral qualities that we impart to the psychophysical coordinates, we can imagine a model of exceptionally rich and sensitive body meanings. It is a comprehensible model (because we "possess" it), although it is much more humanly complex than a mathematical matrix.

The effect of these "possessed" body meanings may be illustrated by examining some likely emotional responses to conditions in the environment. Imagine, for example, being restricted to a totally horizontal set of paths in which only the front/back and right/left orientations are possible. Without the opportunity to ascend and descend, to enjoy

the feelings of aspiring to heaven and then returning to earth, our journey may be a dispirited one. Or consider how an individual crouching in a concrete pillbox experiences the world differently from an individual sitting at a picnic table. (61) A body boundary, or any outer boundary that envelopes the body, which is opaque and difficult to penetrate becomes a surface that gathers and concentrates the forces acting on it from all directions. The forces are magnified on the surface, like the sounds delivered by the knocking on a door. Conversely a boundary which is transparent and penetrable can be expected to stimulate greater fusion between personal and environmental events, whether the boundary be an indefinite personal boundary or a vague outer boundary such as the surrounding expanses of an open field.[32] If the landmarks in the external environment are very close to us, like a nearby wall, we perceive our body as having shrunk, while if we are oriented to an opening in a great space by a doorway, window,

61
An opaque body boundary gathers stimuli at the surface while a transparent one stimulates fusion with external events

vista, or park, we perceive our body as having expanded.[33] (62) When we consciously stare at an object the body boundary hardens and there is a heightened sense of separation, whereas a casual viewing weakens the sense of separation and encourages instead a psychic fusion with the object. And when we very consciously point at something, as opposed to casually gesturing in no particular direction, we feel that our fingers are farther away than otherwise. This phenomenon is similar to the haptic extension of the body boundary we discussed earlier. If we were actually to touch the external object with our hand or an extension of our hand, we would increase the definiteness of our body boundary while psychically shrinking the dimensions of the body part that is doing the touching. Because of the need to balance our bodies in the act of perception, we also unconsciously divide our field of vision into two lateral halves, right and left, and thus extend the form of our personal body space into the extrapersonal space of the environment.

By recognizing that the body is the source of a personal world which generates many of the meanings by which we experience the whole world, we may better understand the role of facial and head expressions. The face is truly a facade which acts as an important sign and message system for the body. Facial expressions and activities are metaphors of experiences that can be, or have been, consummated by the body. In this respect, the face substitutes for the body and takes on some of the

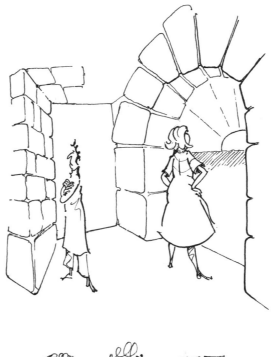

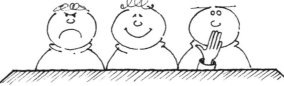

characteristics of a second corporeal center within the bodyscape (albeit a rather two-dimensional and abstract one compared to the rich three-dimensionality of the body). The body meanings of up/down, front/back, right/left, and here-in-the-center that we have identified constitute the background for smiling, frowning, and grimacing, as well as for make-up and hairstyle. (63) The most powerful body experiences, perhaps, are signaled by the eyes, which in body-image literature

62
If landmarks are very close to us, our body seems to shrink, whereas a vista makes us feel our body has expanded

63
The meanings of up/down, front/back, right/left, and here-in-the-center are expressed in our smiles and grimaces

are identified as having "taking-in" and "incorporative-like" significance.[34] A hunger (sexual, for food, or for living space) may be expressed by wide and consuming eyes. A threat or a desire to possess may be signaled by a stare. Thus, through their capacity to simplify, to abstract and allude to needs, facial expressions, acting as the facade for the body, may be employed to dramatize or disguise actual feelings.

Studies of how an individual develops a body image provide clues about our feelings of architectural form, especially feelings about our sense of a centerplace. The body image, as we noted earlier, is formed fundamentally from haptic and orienting experiences early in life. Our visual images are developed later on, and depend for their meaning on primal experiences that were acquired haptically. For example, we jump out of the way when we *see* a car coming, because we know from *bumping into* hard things that there is considerable danger in colliding bodily with so powerful a moving object. (Similarly the meanings we assign to buildings are first known haptically, and visual messages in the design signal and recall more fundamental haptic properties by illuminating or disguising a building's invitations, dangers, and complexities.) Thus haptic experiences which include the entire body give fundamental meanings to visual experiences, while visual experiences serve to communicate those meanings back to the body.

Of course haptic experiences are not limited to the experiences of childhood; otherwise, as Aristo-

tle pointed out, we would be quite dead before adulthood. The discovery of the self as an articulate, delineated, and functioning entity occurs in early childhood, but the spatial forms of that discovery are carried over into adulthood and serve, often unconsciously, as reminders of an extraordinarily rich human identity. Although it is not possible in adult life to create a new identity (however much it may seem that we are trying to do just that), we do recapitulate, re-create, and continue to expand our actual identity. This is an activity we signify in the word "recreation," but one which also has been ignored in many of the architectural settings in which we spend much time.

One of the most hazardous consequences of suppressing bodily experiences and themes in adult life may be a diminished ability to remember who and what we are. The expansion of our actual identity requires greater recognition of our sense of internal space as well as of the space around our bodies. Certainly if we continue to focus radically on external and novel experiences and on the sights and sounds delivered to us from the environment to the exclusion of renewing and expanding our primordial haptic experiences, we risk diminishing our access to a wealth of sensual detail developed within ourselves — our feelings of rhythm, of hard and soft edges, of huge and tiny elements, of openings and closures, and a myriad of landmarks and directions which, if taken together, form the core of our human identity.

6 Body, Memory, and Community

The heart of the distinction we are making between the "feeling" of space developed by the whole body and the "objective" space described through mathematical and graphic measurement is that objective space does not require the existence of a centerplace. Body spatiality, by contrast, refers to an internal world which is not only distinct from and within an external world, but which is centered around "landmarks" and bodily memories that reflect a lifetime of events encountered outside the psychic body boundary.

The social properties of the body image are formed by reactions to people and social events and are thus as dependent on the attitudes of people who have been encountered (and the circumstances of the encounter) as on the fundamental body actions and desires of the individual.[35]

Paul Schilder, in his treatment of the sociology of the body image,[36] sharply refuted the nineteenth-century concept of empathy, specifically, Theodor Lipps's idea of *Einfühlung*. Lipps had characterized empathy as the objective enjoyment of "self" in another person or object. He had suggested that the sense of beauty was dependent on the extent to which the beholder could detect his own private identity in the activities of another person or object. When you apply this model to two people, one trying to demonstrate beauty to the other, however, problems appear, for there is no way for the second person to fully experience the first person's feeling of beauty, short of directly imitating the demonstrator's self-directed activity. (64) This imitation must be seen as either unsatisfactory or impossible.

Schilder, on the other hand, argued that we do not enjoy just ourselves in other people and objects, but instead we attempt to enjoy people for themselves, as others. As an individual develops his personal, internal world, he also develops a curiosity about the existence and nature of another's world. In this respect, feelings are seen as social and other-directed, even when experienced

64
One person trying to explain to another how the beauty in an object lies in his detection of himself in it

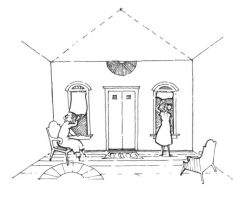

65
People drawing shades, commonly establishing a boundary between themselves and the outside world

66
Symmetrical bushes flank the front door (like whiskers on a cat) as the house faces the public realm

in isolation, for "humanity is the unseen listener."[37]

If feelings are social, so is the emotional spatiality of the human body, with all the meanings which find expression along its boundaries, centers, and psychophysical coordinates. Indeed it is impossible to imagine a spatial organization more universal, more valued, and more immediately understandable to everyone than the one provided by the human body. All of us have been conscious of our "spatial" sensibility at one time or another, and we are most likely curious about that sensibility in other people's worlds. The curiosity about others' worlds not only allows us to enjoy an external expression of our private feelings, but confirms our own existence in humanity.

The House

The recent and generally accepted association of the body with notions of privacy makes it particularly difficult to imagine the incorporation of the body's feelings into the fabric of community architecture.[38] However, the relationship between a bodily boundary and the house boundary becomes evident when we realize that certain feelings originally associated with body transactions may be evoked by activities within a house. For example, pulling down window shades and locking the front door may replicate the stiffening of a body boundary. And when two persons draw shades on the windows flanking the front door these feelings are

shared. (65) Both people are experiencing events in a similar way and are establishing a common boundary condition between themselves and the outside world. In this way *the house becomes a single-body metaphor for one or more persons.*

Two persons may also share the sense of basic orientation that a single house provides. Many of the circumstances that contribute to that sense occur at the edges of the house. Leaving and entering the house are especially significant events in that they necessitate for house dwellers a reorientation from a place of one or a few people (the house) to a place of many people (the city), or vice versa. Even as the primary body boundary exists between the world of the individual and the community, the house boundary exists between the family and the community. The entryway, therefore, becomes an extraordinarily sensitive region of the house boundary, a landmark which must respect and reinforce the feelings and identity of both the inside and outside communities.

Front doors and house facades almost always exhibit a measure of symmetry. In traditional architecture this was achieved with porticoes and balanced facades, whereas today the symmetry is more likely to be expressed by special bushes standing guard at each side of the front entrance. (66) This is certainly related to the frontal "symmetry of mobilization" characteristic of body posture, where the eyes and ears are focused for defense. In houses these symmetries are facial and are usually oriented toward the public. They may

not always represent the most conveniently used entrances (which may be breezeways, garages, or kitchen doors). Front entrances are choice places which generally have the dimensions of an architectural microcosm partly belonging to and largely expressing public values, but "possessed" by the house. This is not true of back entrances, which seldom exhibit symmetry and which serve the private and earthy functions of family life. Backyards are generally without public paths and are almost always distinctly marked by boundaries set at some distance from the house itself. You may have walls in thickly settled communities, or stretches of open space, planting, and woods in country settings. The public is expected to keep its distance from these family gardens.

Of particular concern to us here is the recognition that the different families cannot function fully without the existence of articulate and dynamic outer edges. We know that the action and judgments of an individual may be impaired by a damaged or distorted body boundary, and we realize that the activities of a household may also be impaired by the jamming of its doors and windows. The architectural boundary exists to encourage and ritualize activities which are sacred to the family, and its destruction or exaggeration can sap the vitality of both the family and the public domain in which it resides.

A house is the most personal possession of the family it serves, and that family expects to be able to occupy all its parts. It is worth noting the distinction between a house and a cell in these terms: a cell is a domain which sets out to deny its occupants access to the whole of the place which contains the cell. The front door of a prison, for example, is not accessible to the occupants of its cells, nor are attics, cellars, and grand interior meeting places available to the tenants of most modern apartment "complexes."

Possession (of a house, like a body) is a feeling that calls on all the senses but is the direct consequence of feelings that are confirmed haptically, in contrast to the more distant and figurative feelings that are experienced visually and audially. Thus a feeling of house-possession is reinforced by the opportunity to color and decorate the walls, to touch and alter the landscape that surrounds it, as well as the domestic prerogative to sit on the roof if one pleases. If these haptic experiences are open to all members of the household, the feeling of possessing a single house will be shared by the whole group.

As we noted earlier, a body organizes stimuli about a centerplace, and in the body posture that centerplace is felt to have something above and below it. The most basic orientation of house is up/down, for that is the dimension by which the house asserts its physical location in the landscape. The experiences attached to ascending or descending from the center of the house celebrate values constituted by the family rather than the more public institutions outside; and while individual families may zone the vertical functions of their

homes differently, the architectural potential of that dimension remains available for the expression of personal feelings. The directional choices delivered by the location and articulation of the stairway, or even a single step, embody aspirations and hesitations silently (like a child sitting halfway up the staircase tacitly announcing that he is either going to make a run for it or return to the formalities of a family gathering). Exiting abrubtly through a doorway in the horizontal dimension, especially by opening and closing a door, is a more self-conscious and terminal act than the more subtle shift of orientation via stairs and landings (assuming they have not been designed exclusively for efficient and direct movement, such as a stairwell in a hallway isolated from the communal activity).

Architectural embodiments of *up* may literally designate aloofness, detachment, privacy, and rumination. Thus the attic can become a special communal hideaway as well as a repository of dusty memories. Down is of the earth and carries more the implications of a cave. Stairways to the cellar are usually hidden from public view, while stairways to the upper levels of the house range from modest to elegant dramatizations of the more noble activity of ascending to, or descending from, the heavens. The function of the smaller, private rooms of a well-articulated house depends, unlike cells, as much on their lively presence in, and their commitment to, the rest of the house, as on their answering a need for isolation and protection from the activities centered in the larger, more public rooms. Sleeping and dressing are especially private experiences which benefit from the design of doors and entryways which architecturally make invitations or announce seclusion without the need to hang out the "do not disturb" sign. Doors to these personal places within the house have a psychic orientation which is facial and inward-looking, toward the body of the house, a miniaturization of the facade and front door of the house facing outward to the city. Any room in the house which reinforces the identity of an individual can be expected to have a stronger front/back characteristic than the large rooms which serve all the members of the household.

In the ecclesiastic architecture of the Middle Ages there was no such room as a studio or study. A monk might have had a writing table attached to the walls of a large public room (like an open stall in a modern library), or parishioners might meditate privately in small open chapels along the perimeter of a church nave. It was only during the development of secular architecture in the Renaissance that the modern studio emerged to express a new individualism and a freedom of scholarly inquiry apart from the authority of the Church. The *estudiolo* became a place filled with private artifacts of knowledge (books, paintings, globes, and scientific instruments) which a single person could reserve for his exclusive use. Indeed, the modern movement toward individualism, which we are still witnessing today in the demand for studio

rooms and studies (or offices in some cases) for each member of the family, is making the house into a more "public" place. The commonly shared rooms must take on an even greater sense of center in order to incorporate the greater stimulus of so many social activities and independent personal orientations. Architecturally, this implies stronger expressions of verticality in public rooms, both physically (in order to see and celebrate the many faces within the house) and psychologically, as an expression of a dwelling place in which *up, middle,* and *down* describe their communal location in the landscape.

Memories at the Center

The historic overemphasis on seeing as the primary sensual activity in architecture necessarily leads us away from our bodies. This results in an architectural model which is not only experientially imbalanced but in danger of being restrictive and exclusive, such as a small house with a huge picture window and practically no centerplace. An emphasis on the outer-directed senses encourages the notion that the outside world is bigger than the inside world, a notion which is quantitatively correct but experientially incorrect, especially when we consider that all sensory activity is accompanied by a bodily reaction. The personal world of the body is a redoubt, a place to turn toward. If it is suppressed or emptied of meaning and memory in architecture, how can it react effectively to exter-

nal stimuli? How can it provide an alternative to excessive and disorienting events in the environment? To diminish the importance of the body's internal values is to diminish our opportunity to make responses that remind us of our personal identity, responses we may have had as children when we were playing house or exploring the outdoors. Gaston Bachelard, in the *Poetics of Space,* provides the example of Emily who

had been playing house in a nook right in the bow [of a boat] and tiring of it [she] was walking rather aimlessly aft . . . when it suddenly flashed into her mind that she was SHE.[39]

Emily was neither particularly conscious of, nor looking at, the center from which she was departing, nor the center toward which she was walking, but she was able to detect her identity in the bodily act of moving from one center to another. She recognized that she had been withdrawn and was now emerging.

Although we cannot see the inside of our body, we do develop memories of an inside world that include a panorama of experiences taken from the environment and etched into the "feelings" of our identity over a lifetime of personal encounters with the world. We populate our inside world with the people, places, and events that we "felt" at one time in the outside world, and we associate those events with the feelings themselves. The centerplace of the house, like the body, accumulates memories that may have the characteristics of

49

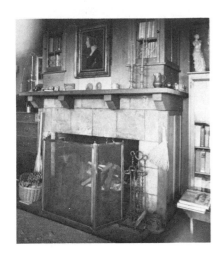

"feelings" rather than data. Rituals over time leave their impression on the walls and forms of the interior and endow the rooms with artifacts which give us access to previous experiences.

These centerplaces in the house are the regions where the memories of the self can be ritualized and new memories belonging to the family can be accumulated and re-experienced away from the distractions which must occur along the outer boundaries of the house. Like the sanctuaries of ecclesiastical architecture or the stately halls of palace architecture, centerplaces in houses embody a reference to a communal human identity transformed architecturally to magnify and add meaning to the rituals and improvizations of the household. In addition to serving social rituals the centerplace often recalls and celebrates the basic life-supporting elements.

In the North American country house, for example, the anachronistic wood-burning fireplace with its hard and well-crafted mantle has been conserved as an icon well beyond its mechanical function. (67) The hearth is surrounded with treasures and memorabilia. In the Mexican country house the fountain has been in like manner conserved and is employed often as a well-crafted centerpiece in a courtyard surrounded by tiles, plants, bird cages, and memorabilia. (68, 69) In many houses a garden is incorporated with carefully controlled and nursed planting, whether in the small front yard of a German village house, around the perimeter or on the terraces of an

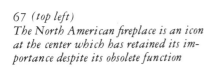

67 (top left)
The North American fireplace is an icon at the center which has retained its importance despite its obsolete function

68, 69
The Mexican fountain in the patio is likewise an icon at the center

American house, or within the walled courtyard of a Mexican or Japanese house. These are microcosms of earth, air, fire, and water which renew our recollections of a world inhabited over time, of primal beginnings not yet altogether forgotten. Thus, while the entire house may be characterized as a single-body metaphor for several persons within the house, the centerplace of the house may be better understood as a place in which memories of the world outside the house are "domesticated," protected, and re-experienced.

The proximity of some family treasures to the hearth provides the house with an icon (or treasury) that may be regarded as possessing uniquely haptic properties. A portrait or a clock is to be seen and heard, but the heat from the fire, the rushing water in the fountain, and the smooth tactile objects on the mantle deliver feelings of touch and even permanence. Here the lifetime memories of the person collaborate with the timelessness of the world outside. The stone and wood of the house itself are embodied in these memorable centerplaces and even they belong to the body of memory.

One profound difference between the human body and the house, of course, is that we cannot see into the human body or walk through it, while we do penetrate the boundaries of the house and arrive at its center space. So a choice arises: whether arrival at the center comes as the climax of a carefully choreographed continuous route from entrance through predictable intermediate zones to the heart (as through the New England front door

past a hall to the central room and its fireplace), or whether arrival at the center comes as a surprise, like arriving at the patio in a dense Middle Eastern house. Both continuity and surprise have worked well, and both are available to us.

The same orientations and sensibilities that function in the house must also exist in the city if it is to have a human identity. An elegant landmark in a house, such as a mantle clock, may appear as an urban landmark in the form of a lofty clock tower. (70, 71) Or a dramatic staircase may assume an even

70, 71
A civic landmark, such as the clocktower on New Haven City Hall, may take its form from a domestic landmark, such as a mantle clock

72, 73
A dramatic domestic staircase, such as at Rosecliff in Newport, Rhode Island, may take on an even grander aspect in the public sector, as do the Spanish Steps in Rome

grander guise in the public sector. (72, 73) A fountain such as the one in the courtyard of the Mexican house but perhaps more imposing may be the most appropriate and memorable centerpiece for the public square. (74) Symmetrically positioned gate posts or planting which so often embellish the front of the house may find their giant counterparts in the statuary of an enormous bridge or in the landscaped parks at the boundaries of public institutions. (75, 76) Public parks both in the center and along the edges of the city are the giant gardens of the city-house. Thus the bodily elements of doorway, window, centerpiece, and even roofscape that find their expression in the form of a house may occur again and again until they achieve the dimensions of a city, while conversely a glass monument which marks the government center of a small city may celebrate feelings of a new place beginning in the heart of the old. On a more intimate commercial scale, a new storefront does

74 (top left)
The fountain in the patio reappears as the public fountain in the plaza, as in Lovejoy Plaza in Portland, Oregon

75, 76
The gateposts that flank the front entrance of a house (above) appear in a public version at the Soldiers and Sailors Memorial, Hartford, Connecticut (below)

the same by recalling in miniature the forms of the newer glass buildings in the surround. (77, 78) By maintaining recognizable artifacts at key points along the boundaries and in the center of public places the identity of the human can be projected outward into the community or back into it.

There should be no fundamental difference between the way we might orient ourselves spatially to the inside world of a great metropolis and the inside world of a house. Both require the feeling of

being bounded, possessed, and centered (as anyone driving into an unfamiliar city will testify). How comfortable and inspiring it is to move into a city with a grand entrance, be it a suspension bridge or medieval wall, and then to feel one's way to the center or centers by way of recognizable landmarks, such as towers or a plaza or other visible points en route.

No matter how spectacular the forms of the buildings within the city may be to the eyes of its

77
Cesar Pelli's San Bernardino City Hall celebrates feelings of a new place in the heart of the old

54

citizens, the meanings and feelings that the buildings give will be diminished if those buildings cannot be "possessed." It is not difficult to imagine the sense of disenfranchisement of a city dweller who gazes at the silhouettes of objects within a great city while he is kept back with de facto "keep off the grass" signs. And as with the house, those experiences which generate the feeling of possession can be localized around highly sensitized landmarks, especially along boundaries and centerplaces, as in the banks, promenades, and possible "lookouts" of the city.* The haptic experiences upon which the feeling of actually possessing a house depends must apply to the city as well if the city is to belong to its constituency.

*Actually the form of the body already dictates the form of the city, albeit somewhat unconsciously and in ways that do not always generate feelings of public possession. Our entire traffic network is a system of right and left sidedness, a sensibility incorporated in the design of our traffic grids and intricate cloverleafs, and reflected as well in the rules governing stairway traffic. We seem to take handedness for granted in matters of communal mobility where physical accidents must be prevented, but we pay less attention to its presence as an environmental sensibility in our choreography of buildings and small places.

78
George Ranalli's "First of August" dress shop in New York City recollects in miniature the glass walls that surround it

79
The Caryatids of the Acropolis, un-
daunted by their burden, seem ready to
step out into the mortal world

7 Body Movement Robert J. Yudell

The interplay between the world of our bodies and the world of our dwelling places is always in flux. We make places that are an expression of our haptic experiences even as these experiences are generated by the places we have already created. Whether we are conscious or innocent of this process, our bodies and our movements are in constant dialogue with our buildings.

There is, perhaps, no more clear and powerful image of our relation to the forms built with our own hands than the caryatids of ancient Greek temples. These young maidens, carrying the weight of ornamented and inhabited entablature and pediment, stand serenely, seemingly not burdened by the transfer of a great load. They establish the link between earth and sky, between the rocks upon which they stand and the gods whose lives are recorded in the pediment. Nor are they static or frozen in this role. Undaunted by their special burden, they express the potential for movement as, with raised knee, they are ready to

venture with ease and certainty into the space of their mortal world. This image of humankind carved into architecture affirms our place in the world. (79)

As with the caryatids, our movements are ever subject to the same physical forces as are built forms and may be physically contained, limited, and directed by these forms. Inevitably they are more intricately entwined with and dependent upon architecture than are the sound and notation expressions of conversation, song, music, and writing. This critical interaction of body form and movement with architecture deserves careful attention.

The Spatiality of Movement

It is not surprising that forms are more often the focus of our attention than space or movement in space. Space is typically thought of as a void or as the absence of solid, and movement thought of as a

domain separate from its existence in space.

We can look to the dancer for some fresh sense of these realms. Dancers speak of "feeling" space. This ether through which most of us look, focusing on solid objects, becomes real "stuff" to the dancers. Martha Graham, the doyenne of modern dance in this country, would regularly base a set of exercises on the haptic experience of space; her students were asked to hold, push, pull, and touch pieces of space and places in space. A natural outcome of this kind of training is that the entire body gradually is mobilized to touch and feel space, so that movement becomes not a vague indescribable set of reflex actions, but an articulately felt interaction with the positive stuff of space. The dancer and the space animate one another as partners.

If dancers feel a critical relationship to the space outside their bodies, they also sense an essential relationship to the inside. In forms as divergent as classical ballet and modern dance the practitioners speak of the constant need to find or feel one's "center." This is usually described as being in the region of the deep abdominal muscles, but the location is not as important as the fact that the "center," the inside, must be felt before the dancer can confidently move in space, the outside. This is, indeed, reminiscent of our need to sense the security inside our dwelling place in order to act with strength in the outside community.

A vital aspect of the dancer's maintenance of a sense of body center while moving in space is the continuous awareness of the pull of gravity. This omnipresent force that we seldom consciously consider is the object of the dancer's acute awareness. Dancers' responses to gravity have been varied but always intense, almost obsessive. Ballet has developed, in part, as the art of denying gravity, and years of technical training are devoted to creating the illusion of effortless leaps and flutters through space. With contrary intention but an equally powerful response, much of modern dance and folk dance displays and celebrates the pull and power of the earth with the actions of falling, stomping, and embracing the ground. In one of the revolutionary acts of early modern dance, Mary Wigman scandalized German audiences by bumping her way across the stage on her back, feet, and hands. In this performance of 1919 she was saying that gravity, the earth, and down are real and that we are inevitably bound by such powers.

Thus "center" is not a concept of geometry but one of the musculature with all its kinesthetic ramifications, of orientation in response to the pull of gravity, and of a sense or feeling of inside.

Looking at the body in space, we find that geometric abstractions and descriptions quickly assume layers of associative meaning. Rudolf Laban, an influential pioneer in graphic notation for dance, has described movement in terms of the "frontal," "vertical," and "horizontal" planes, providing a triaxial structure remarkably similar to the psychophysical coordinates of the body-image theorists.[40] A look at the vertical and horizontal

dimensions is especially relevant to movement in architectural space.

The standing figure becomes a symbol as well as an element of the vertical axis. As the implicit link between earth and sky, he or she becomes the communication between the two realms. And because these realms have radically different properties, the body becomes the matrix for the synthesis and resolution of this polarity. Up and the sky are divine, spiritual, ethereal, light, rarefied, spreading, a canopy. Down and the earth are material, mineral, dark, compact, firm, a solid, a cave.

Movement upward can be interpreted as a metaphor of growth, longing, and reaching, and movement downward as one of absorption, submersion, and compression. Since the images of womb and tomb are associated with the earth, and images of resurrection and the afterlife are related to the sky, the vertical axis is also closely bound to the concept of transition through the cycles of life.

In contrast, movement in the horizontal plane relates only to the earthly stage in that cycle. Laban has identified this plane as the zone of communication and social interaction. The communication or change, however, is not related to the personal longing which is associated with the vertical axis.

All human movement traces complex spatial configurations. Its forms can be seen as a compounding of movements through the spatial axes—a process continually changing in time. Curvilinear and diagonal motions are developed in relation to the two axes, while spiral and helical motions are developed in relation to three axes. It is interesting to note that movement in two axes or one plane, such as walking, running, and most forms of human locomotion, is the most prevalent mode in a typical day's activities. Movement in one dimension, such as diving into the water (a very tightly defined and restricted movement), and movement relative to three dimensions, such as the baseball player's wind-up (a very spatially complex and dynamically changing movement), are both exceptions to our normal patterns.

Although we are capable of an infinite range of movements, most of us move within a fairly narrow range of our possible spectrum. One of the critical determinants of this range is the built environment: the spaces and stuff that we construct and inhabit.

The Building as a Stimulus for Movement

All architecture functions as a potential stimulus for movement, real or imagined. A building is an incitement to action, a stage for movement and interaction. It is one partner in a dialogue with the body.

We need only recollect our own childhood activities to see how easily sparked is the haptic interaction of body form with built form. Consider the simple game of stepping on every crack in the sidewalk. Here the child plays his body (its dimensions, shapes, and rhythms) against the given grid of the sidewalk paving. Usually the chance cracks

are integrated into the game, thus complicating the time and movement patterns that are developed. Or consider the game of hopscotch. Here a bilaterally symmetrical chalk grid is the "structure" with which the body plays. Variations in the speed, rhythm, and dynamic of the movement are rather simply induced by the configuration of the grid; fast, less stable movement through the single-box-one-leg hops, slower, more controlled and balanced movement through the double-box-two-leg maneuvers, and jump turns at the ends of the grid. In both games the body is stimulated by the physical pattern into an interaction which generates a kind of spontaneous primitive dance. It is an experience almost all of us have shared and of which we are still capable.

Another common experience, running a stick along a picket or cyclone fence, also shares these characteristics. The regular periodic spacing of the pickets or steel wire is the "Cartesian" given of the built environment. The rhythmic variables are the speed and pacing with which the child or "musician" moves against the grid. Here a kind of music is the product, and the importance of both the animate and inanimate participants is heightened.

The ebbs and flows, weights, rhythms, and surges that emanate from us are inherent in the body and its movements. Try to walk in precise and even measures. Even if you succeed in doing so horizontally, as in a march, there will still be complex rhythmic events in the vertical dimension

(the raising and lowering of the chest with breathing and the changes in the relative alignment of body weight), not to mention the internal rhythms of heart and pulse.

Given this rhythmic richness which we all possess, and the fact that patterns as mundane as pavement cracks and picket fences can elicit complex haptic responses, we might well wonder why any building cannot be as good as the next in generating a body response. Why are we not *moved* by our neighborhood shopping mall or city center office tower? Take, for example, a typical curtain-wall skyscraper. Its potential for pulling us into the realm of a movement or sound game is almost nil. We can neither measure ourselves against it nor imagine a bodily participation. Our bodily response is reduced to little more than a craned head, wide eyes, and perhaps an open jaw in appreciation of some magnificent height or of some elegantly prescribed mullion detailing. (80)

Compare this with a 1930s ziggurat skyscraper such as the Chrysler building. (81) Here we have not only the vertical differentiation of the building but chunky setbacks which conjure landscapes or grand stairways. We can imagine scaling, leaping, and occupying its surface and interstices. Even the cheap and efficient stepped-back curtain-wall buildings erected along New York City's Park Avenue in the 1950s and 1960s provide us with some form of imagined cubic landscape, in spite of their forfeiture of body relation at smaller scale and at street level. (82) A section through a street

80 (opposite)
The most that an ordinary curtain-wall prism can elicit from us is a craned head and perhaps an open jaw

81
But we can imagine ourselves occupying the pinnacles of the Chrysler building

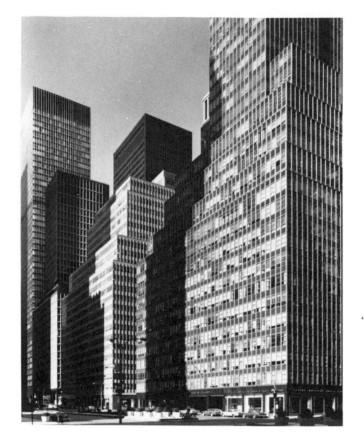

flanked by ziggurat buildings yields the "canyon," (83) quite different from the tight, unpenetrated slot that the sheer curtain-wall towers produce. By these we are given not the "canyon" but the "shaft," (84) and the difference in imagery is significant. Man can climb into and out of a canyon, but traditionally his way into and out of a vertical shaft must be aided, usually by some form of mechanical lift. He is therefore rendered somewhat less independent and considerably less mobile. He is now the object of an operation, not the subject of an action, and this change has important implications for his sense of himself and his strength and vitality. Even Superman could not leap out of the shaft in one of his "single bounds."

In periods when people were excited about new ideas for grand action in the environment, their buildings and visions seemed to reflect a more acute sense of what the body could or should become. The "King's Dream of New York" of

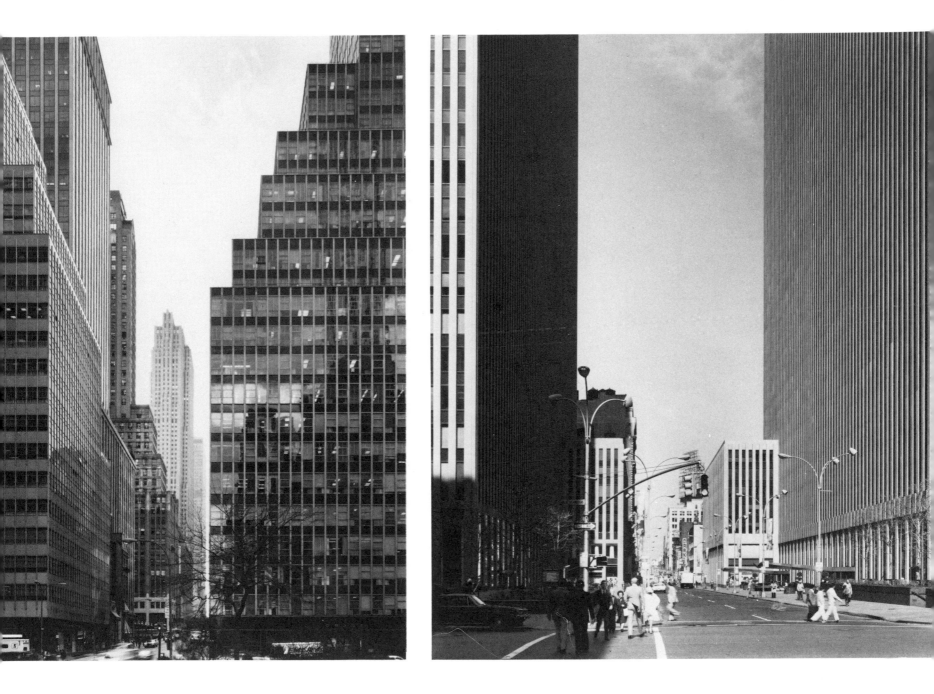

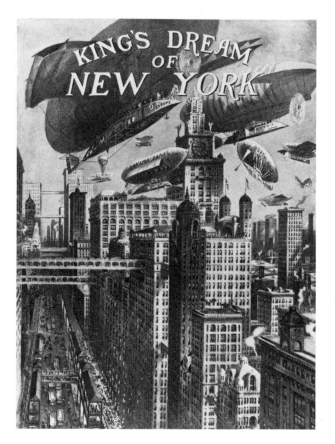

1908, an illustrated tract conceived at a time when builders were aroused by the possibilities presented to them by new steel-frame building technologies, depicts throngs of citizens brushing by buildings in dirigibles, partying on skyscraper rooftops, and rushing across the trestle bridges high above multilayered streets and rapid transit traffic. (85) It was a vibrant image of action. Only a few years later, and in sharp contrast, Sant' Elia's futurist visions show a fascination with the speed and movement promised by new technologies. Streamlined vehicles streak through elegant machinelike building forms, but never is there a glance at a body in action. (86) Much as in the "shaft," the body must again be moved, while in the "King's Dream" we could still move ourselves.

Some of the most vivid and energizing images of the body in space come out of Russia in the years closely bracketing the Revolution. The majority of political posters by designers of this period feature man in action as the dominant theme. (87, 88) Bodies are leaping and flying through space, often in collage with elements of building form. These images impart tremendous excitement and confidence but also a sense of imbalance. It is surely no coincidence that diagonal movement through space is a persistent image. For by its nature diagonal motion is less easily oriented and its termination less predictable than that of either pure horizontal or pure vertical motion. In fact, diagonal motion appears to be related to quick change or upset in an existing order. The space of

85
Citizens were in action in "King's Dream of New York" in 1908

86
In Sant' Elia's visions not much later, the human body in action never appears

Western cultures is usually ordered in a rectangular grid. When we want a short cut, a quick transition, a transformation, we cut through at a diagonal. The simple act of "cutting through" a neighbor's property or what Broadway does to Manhattan's grid (89) are in the same family of action as that asserted by the Russian Constructivist posters with their vivid diagonal body motions. They were saying "make a new order," but, more important, they were saying "make it with your body."

87
In Russian revolutionary political posters, bodies in action move diagonally across the frame

88
As people and (especially) buildings make a diagonal thrust

89 (below)
In New York, Broadway cuts across the grid

90
Tatlin's Monument to the Third International (1919–20) spirals diagonally

The Building as a Stage for Movement

If one combines the diagonal, the most dynamic single axis, with the spiral, the most spatially complex configuration for body movement, one produces the basic form of Tatlin's Monument to the Third International. (90) Even the static model of this unbuilt Utopian vision seems to streak and spin through space, implying a movement which begins with the building itself but which shoots out into space and the future. Indeed, the inner cylinder of the structure itself, housing conference and meeting rooms, was to have revolved about its axis once a year. There is an excitement here which goes beyond technology to man's role as an active agent.

If this vision acts as a call to move, it also implies a stage and arena for the movement and for the complex interactions of many bodies in motion. In those Russian posters the energy of the bodies was more than the sum of the parts. Compositionally a new whole was made by the relationship of the bodies to one another and by their further relationship to built or planar form.

Similarly, buildings can encourage a choreography of dynamic relationships among the persons moving within their domains. Hans Scharoun accomplishes this in the foyer of his Berlin Philharmonic Concert Hall by slipping cascades of stairs over and under one another in diagonal relationships that begin to challenge one's sense of order and orientation. (91) A surprisingly similar and

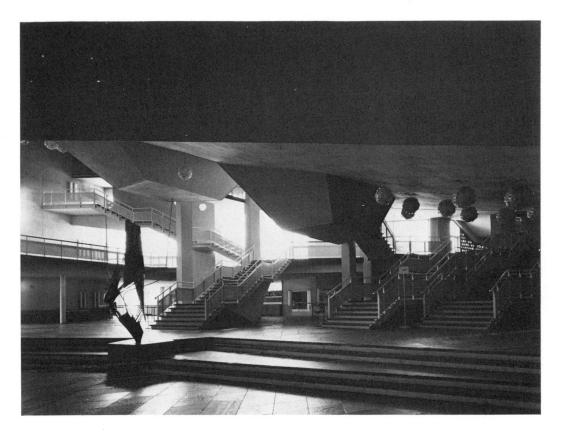

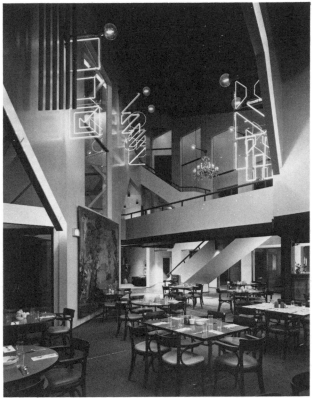

equally dynamic phenomenon can be seen in Moore/Turnbull's Faculty Club in Santa Barbara. (92) In both places people and their paths spin out a somewhat frenetic and highly energized spatial configuration. The potential disorientation forces on us an awareness of our own movements as well as our spatial relationships to one another. The tendency toward disorientation seems acceptable, even healthy, because it is so overt. We are put on alert and can respond to the situation. It is, in that sense, similar to climbing a tricky slope: one's

91
The stairways in Hans Scharoun's Berlin Philharmonic encourage dynamic interrelationships

92
As do those at the University of California Faculty Club in Santa Barbara

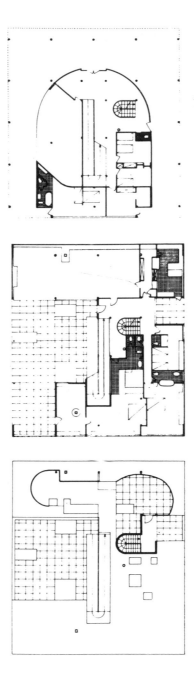

senses are heightened and one's bodily responses are quickened. Since we cannot, however, regularly function on the edge of disorientation or in the frenzy of dynamic complexity, stimulating though it may be in short exposures, we must employ other equally rich but more subtle means of experiencing one another and space.

Le Corbusier is masterful in his elegant weaving of different kinds and patterns of movement. In the Villa Savoie, for example, he provides two paths of vertical circulation. (93) One, a spiral stairway, is clockwise, curvilinear, and incremental in its vertical progression. The other, a ramp, is counterclockwise, rectilinear, and continuous in its vertical progression. These are related at a 90° angle to each other so that they have one point of near tangency. (94) In addition the paths are arranged so that this zone of tangency corresponds to the mid-level of the stair path and the full level of the ramp path. Thus, by an exceedingly skillful arrangement of otherwise fairly standard architectural elements, he has generated a highly complex periodic pattern of space–time relationships, experienced primarily through body movement. It is most exhilarating when we can sense our movement in relation to a person on the other path; catching and losing sense of that person, playing curve off straight and step off stride. Then we are acutely aware of our own movement by its periodic relation to that of another participant. The architecture takes on more life and gives more as it becomes a stage for movement.

93
In Le Corbusier's Villa Savoie a stair and a ramp play against each other

94 *(opposite)*
At one point they are almost tangent

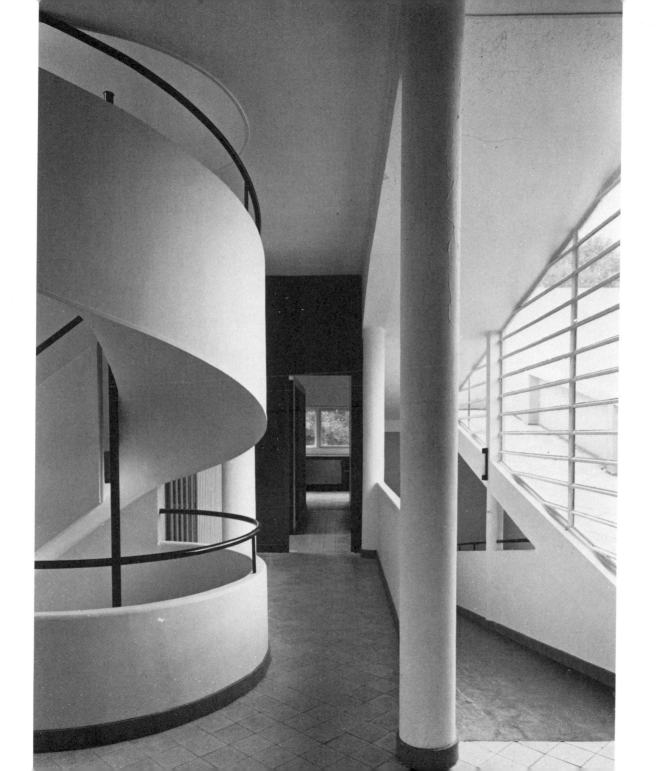

The Building as a Partner in Dialogue

The setting of a stage is but one aspect of the extended dialogue between body and building. We might simply ask what the building tells us about the place of our bodies within and around it. This may have as much to do with static fit ("Where do we sit, lean, nestle?") as with dynamic fit ("Where and how do we move?"). Richard Upjohn's Connecticut State Capitol is ready with answers to these questions. (95, 96) Its corridors, halls, and stairways are faceted with body-sized articulations that welcome our presence. Substantial stone balustrades invite cozy leaning. Niches and bays occur on landings and in halls so that intimate groups can gather. Arches frame the movements of others and layer these images in a complex reticulation. On any weekday all the real business of the legislature appears to be conducted in these amicable places, and the visitor is as welcome as the habitué. It is no accident that the

space is studded with stone carvings of graceful figures. The architect gave the human figure an essential place in the dialogue with his building.

This structure makes a complex but "loose fit" with the body. The body has many places and options within the space. Perhaps the opposite extreme, the "tight fit," can be seen in the Mesa Verde cliff dwellings. Here, for reasons of security, the path of access from the canyon floor to the dwellings is a set of hand- and foot-holes carved into the cliffside. The holes are arranged so that one must start from the bottom with a particular hand or else be stranded precariously just below the village. This exotic relation of body and pattern is not so far removed from the child at play with sidewalk patterns.

The fit and movements of our bodies within and around buildings are also significantly affected by our haptic sense, by the tactile qualities of the surfaces and edges we encounter. Smooth surfaces invite close contact, while rough materials such as hammered concrete generate movement in wide radii around corners and more careful, tentative movement through corridors. Changes of texture often signal special events and can trigger a slowing or quickening of one's pace. It would be possible to generate a whole choreography of movement through the composition of textural changes alone. In fact this has been explored in recent architecture for blind persons, where important spatial cues are produced by the organization of tactile experiences.

95, 96
Some great buildings such as the Connecticut State Capitol make as much of static fit (where do we sit, lean, nestle?) as of dynamic fit (where and how do we move?)

71

Our Repertoire of Movement

The various body motions that are comprised in a typical day's activity constitute what we might call our repertoire of movement. Consider, for instance, the man who lives in suburban Connecticut and commutes to work as a midlevel executive in a 1960s glass office tower. Let's assume he lives in a large but totally horizontal modern ranch house. He takes the train fifty miles into the city, changes to a subway, and walks two or three blocks to his office. There he goes through a small lobby and into an express elevator that takes him a quarter of a mile into the sky. This man is "moving" faster and farther than mankind has ever moved before, but his movement is primarily a passive experience. Ironically, he is actually experiencing less active movement in the horizontal and vertical dimensions than ever before. His office tower, for all its impressive height, is sliced into uniform eight- to ten-foot slabs of space. His house, for all its sprawl, is similarly one slice of horizontal space. This man's counterpart of a century ago might well have walked to work and arrived at a four- to six-story building with no elevators, but with spatially ample vestibules and elaborate public stairways.

In short, in spite of going faster and farther, we seem to be functioning with a reduced repertoire of active movement. We are increasingly replacing our own body movement with propulsion of the immobilized body. We are replacing motion with "frozen speed."

97
There is no body contact for the spaceman

98
Though there was plenty for his adventurous predecessors

The Frozen Body and the Floating Body

Our romantic images underline this development. Compare the mythic explorers of two eras: the modern spaceman and the swashbuckling buccaneer. The former travels distances that defy conception, but he is frozen for most of that travel. He is encapsulated and propelled. Even in his encounters with threatening other-worldly creatures he makes no body contact. He stands statically and lets his ray-gun do its business. (97) But our image of the buccaneer is a man scaling masts, swinging from rigging, pushing his assailants into the sea, and masterfully wielding his sword. He moves and makes contact, and there is grace and beauty in his actions. (98) The man in the spacesuit has lost much of his potential for individual affirmation. He is more the functionary of a far-removed effort.

If the body is becoming frozen and encapsulated in space, it may also be the victim of the opposite excess: becoming unhinged, free floating, and alienated in architectural space. This tendency may well have been foreshadowed fifty years ago by some of the masters of the modern movement. Images in Mies van der Rohe's own renderings often convey a sense of the ungluing of the body from the building. In his 1942 drawing for a small museum, the Maillol figure stands free and solitary in the neutral, gridded, Cartesian space. (99) It is indeed an image of lonely coexistence. The argument may well have been that neutral, undifferentiated space permitted any action and there-

Pencil and cut-out reproductions, 30 x 40". Courtesy, Mies van der Rohe Archive, The Museum of Modern Art, New York.

99
In the Mies Museum for a Small City (1942), a figure stands free and solitary in neutral Cartesian space

fore conferred a new freedom. But unlike the loose fit of buildings such as the Connecticut State Capitol, this leads to no fit at all. Nor is movement either catalyzed or implied.

Insidious Strains of Futurism

In the hands of a brilliant craftsman like Mies van der Rohe, a spatiality of alienation may still provide its rewards through the elegance of material and construction. But the more extreme applications of Cartesian space present an insidious threat to our identity as individuals. The futurist group Superstudio has given us some of the most haunting images of bodily alienation. One of their visions promises the total freedom of living on an infinite gridded platform into which we may plug for energy, information, or nutritive needs. (100) We are assured that, in this Utopia, we shall no longer require clothes or shelter and that we can be transported in an instant to any part of the earth. This scenario embodies a clear denial of the need for the interaction of body and architecture. There are no landmarks, no stimuli, no stages, and no centers.

The other extreme to alienation of the body is overmanipulation of the body. The two are often complimentary phenomena, and it is not surprising that this hypermanipulation is in the domain of some of the same futurists who would have us be neutralized nomads, unhinged from our special places. Members of the Archigram group have

100
Superstudio promises us an infinite gridded platform for complete freedom from place

proposed such future pleasures as "Manzak":

All the sensory equipment you need for environmental information retrieval, and for performing tasks. Direct your business operations, do the shopping, hunt or fish, or just enjoy electronic instamatic voyeurism, from the comfort of your own home.

and the "Electronic Tomato":

For the great indoors, get instant vegetable therapy, from the new Electronic Tomato — a groove gizmo that connects to every nerve end to give you the wildest buzz. [41]

These are surely images of the manipulation and electronic cooption of our bodies and their initiative. (101) It is total passivity. Our bodies are circuited out of our existence as our world is realized in electronically stimulated sensation.

101
A freedom also enjoyed by Archigram's "Manzak" and "Electronic Tomato"

102
In Peking, an axis goes straight north to the Imperial center

8 Place, Path, Pattern, and Edge

The landscape of the human inner world of landmarks, coordinates, hierarchies, and especially boundaries serves, we believe, as the only humane starting point for the organization of the space around us, which, more than being perceived, is inhabited by us. We propose here to look again at the architectural building blocks in the existential space that surrounds us,[42] to pursue them from the boundary of the individual body to the first shared boundary (the house), and beyond that to boundaries shared by larger and larger communities, seeing how they can be a means of extending inner order outward, of making a world that is a sympathetic extension of our sense of ourselves.

The building blocks that mankind long ago invested with meaning were described in chapter one: columns, walls, and the roofs between them; porches and arcades formed by columns; towers to which they stretch up; rooms and hearths which the walls enclose; and doors and windows which relate an inside to the rest of the world. These forms have been important to humankind because they accommodated the initial human act of constructing a dwelling, the first tangible boundary beyond the body, they accommodated the act of inhabiting, and they called attention to the sources of human energy and to our place between heaven and earth.

Beyond that first boundary, the inventory of pieces available to build the world does not really lengthen; the variations are changes not of form, but of position. Though the structures remain the same, the choreography of the trip to them can intensify their importance to us. A clear example is the axial city of Peking. (102) A trip north along the major approach proceeds without deviation through huge and then through smaller gates, past the outer city and inner city, into the Forbidden City, and then to the Imperial compound itself, where the heart of the place, the seat of the emperor, is actually smaller than the great gateway pavilions at the outermost limits of the city. Yet it

103
Monuments are generally placed at the boundaries or at the heart of a place

104
An object in a void

105
A void in a solid

is unquestionably the center, the focus, the Place.

We start with the house (or palace or cathedral) staked out in close homage to the human (or the divine) body and note how the choreography of arrival at the house (the *path* to it) can send out messages and induce experiences which heighten its importance as a place. Far beyond the boundaries of the house lie the edges of cities, and beyond them the outer boundaries of whole societies. Within those larger boundaries are places to live and to work which range from private to shared and which include highly symbolical public realms as well as unclaimed no-places. Monuments marking places of more than private importance will be found most often at either the borders or the heart. (103) And some pattern of connections will be laid upon the earth within those boundaries, generally producing a set of inner edges upon which our comprehension of the place depends.

The inhabited world within boundaries then,

can usefully be ascribed a syntax of *place, path, pattern,* and *edge.* Within each of these four, architectural ordering arrangements can be considered which are made to respond to the natural landscape as well as to human bodies and memories.

Place

Places made with the talismans we have examined must be distinguishable from the world around them. This generally limits them to objects in a void, (104) to voids in a solid, (105) or to special conditions at an edge between voids and solids. (106) The basic list of physical talismans for places is a short one: the cave become cavern or public room, generally lofty, with a ceiling that may recall the sky (107); the enclosed space open to the sky (108); the walled treasury or box, whose body shows clearly from the outside, perhaps modified,

106
Special conditions at the edge

107
The Pantheon: the cave can be a great public cavern

108 (*below*)
Or a space enclosed with walls may be open to the sky

79

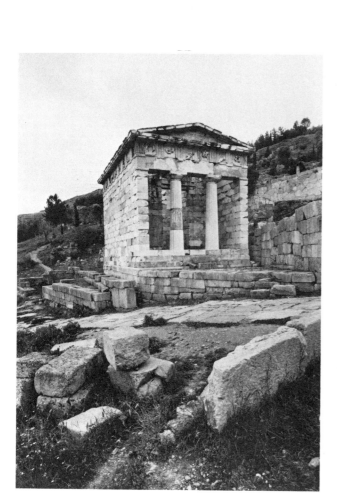

109 (above)
*The body of the Treasury at Delphi
shows from outside*

110
Great Pyramids recall the mountains

111
*Or a dome recalls the sky, as in Karl
Friedrich Schinkel's setting for the Queen
of the Night*

as the human body is, by openings (109); the perfect geometric form, perhaps at odds with the natural world, perhaps recalling it, as the great pyramids recall the mountains or the dome the sky. (110, 111) Columns may be employed in concert to make a mediating porch, or used singly, as a tower at the center or edge of the realm. (112, 113) Within a different time span, flags and banners can have the same memorializing function as the tower, (114) with the added sense of immediacy

112
Columns can be used singly as a tower, as at San Gimignano

113
Or employed in concert

114 (opposite top)
Flags and banners mark places as towers do

115 (opposite bottom)
And tents can mark places of celebration

116
A central forum can take many forms

and attention to the here and now (analagous, for example, to the Indian act of laying a fresh flower on an old stone altar). A place-marking device with qualities of both the tower and the flag is the tent or the tented pavilion; recollective once of the power of nomadic conquerors, today it signals festivity and celebration, a special event in time, or even a seasonal pleasure, like the awnings of a sidewalk cafe. (115)

Though the communal pleasures of hearth and fire have long ago died out except in very special places such as the Zuñi pueblo, the centrality of forum — a place indoors or out where people can assemble to have a town meeting, or see or stage a spectacle, or talk, or collect signatures (116) — is still important to us (though electronic communication and the takeover of the public realm by the privately owned shopping center are casting long shadows over this fragile part of the public life; it is very difficult, for instance, to engage in political activity in most shopping malls).

The prime characteristic of a public place is public inhabitability, either in the full sense of people feeling naturally at home there (as Venetians seem to in the Piazza di San Marco, or Londoners do in their parks) (117, 118) or at least in the sense of there being allies in inhabitation (as the statues in the Palazzo Vecchio in Florence, or the flowers in the streets of Spanish cities, or the fountains in Rome, or even the light across the white surfaces of Mykonos). (119–121) The great blank horrors of our public environment are the spaces that belong to no one, that are neither private nor public, neither comfortable nor inspiring nor even safe, the no-places that erode the public realm. (122)

117 (top left)
Venetians feel at home in the Piazza di San Marco

118 (top right)
Londoners inhabit their parks

119 (bottom)
The statues in front of the Palazzo Vecchio are allies in inhabitation

120 (top left)
The flowers in Sevilla help inhabit the spaces

121 (top right)
The moving light in a Greek village is an ally in inhabitation too

122 (bottom)
But some spaces defy inhabitation

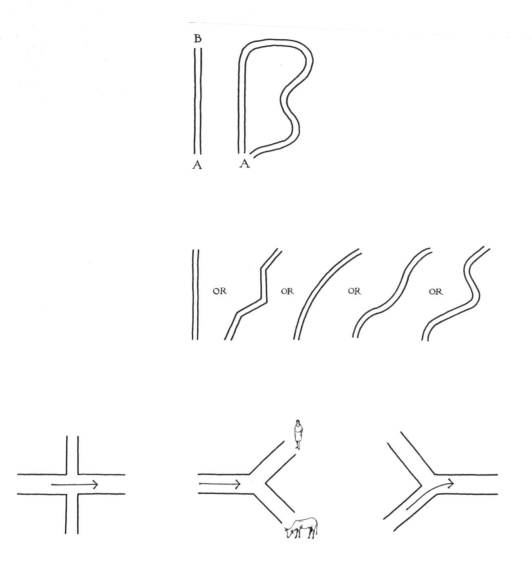

Path

Paths too are of a limited variety. They can go from one point to another, or they can return to the point from which they started. They can go from point to point in a straight line or in a series of lines, or in a curve or series of curves, or in a combination of curves and straight segments. They can of course intersect. (123–125) Here, the basic experiential differences have the most to do with the decisions that have to be made: an intersection can help measure the time of travel but does not otherwise complicate the route or force any decisions; a branch forces a decision; confluence can modify the path but requires no decisions.

All these paths can be going up, or down, or maintain one level, and a special sense of the self corresponds with each of these (especially up and down). (126) Not long ago architects were careful to place ladies' rooms several steps above public spaces to facilitate graceful entry into the public space, while men's rooms were placed below the main space to minimize the drama of the gentlemen's return. In the men's locker room at the larger Swim Club at the Sea Ranch in California, the skylit shower is a few steps below the dressing bench, and the sauna and plunge below that, to take advantage of one's special sense of self without clothes, and the pleasure of moving on stairs in the light. The temple complex at Monte Alban in Mexico seems to have been built around the act of climbing. (127) There, thousands of feet above the

123
Paths can go from A to B, or back to A

124
In combinations of straight lines and curves

125
And they can intersect

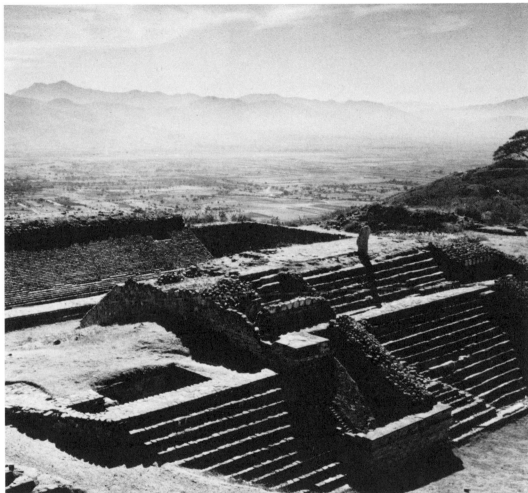

126
In a locker room, steps animate the path

127
*In Monte Alban the act of climbing
takes on ritual significance*

128
There are simultaneous paths for the eye and the feet

129 (opposite)
And paths for the eye and mind inaccessible to the feet, like the blind stairs in a Piranesi prison

valley floor, a flat plaza was made from which each temple was entered, up a flight of steps, then down, then up again higher to the special place. To arrive at the largest temple, one went up, then down, then up, then down, then farther up again. Great Baroque gestures, too, such as the Spanish Steps in Rome, (see 73) made the act of walking up and down and lingering so absorbing that the goal, the place, is subsumed in the path; getting there is *all* the fun.

Another variation is introduced by the difference between the path one's body is actually traveling and the eyes' capacity to take in the route in larger leaps, or along an alternative route, or even all at once. (128) The imagination can even perceive places where the feet cannot reach. The mysteries of the Piranesi prison series (129) or of Escher's drawings come from a description of this realm, but we experience it often as we pass people on the escalator going in an opposite direction, or

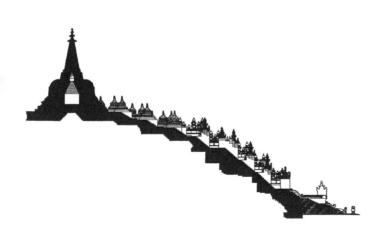

thread the intricacies of a superhighway interchange. Imagination extends greatly the realm of the moving body and the richness of path. As the eye sweeps up around the Pantheon, or into the intricacies of a dome by Guarino Guarini, (130) or into the triforium of a Gothic cathedral, it is in some measure bringing the body along on paths it can surmise but not achieve. Borobodur in Java, a Buddhist stupa, is a very special place which is reached by the ritual act of circumambulation, around and around on foot to the top. (131) It is first cousin to a tile pattern from the Alhambra, which lets one's eyes alone traverse its intricately overlaid patterns. (132)

The two acts of moving with the body and the mind's eye can even be put into conflict, as in

130 (opposite)
The eyes alone take in the intricacies of a dome by Guarino Guarini

131
Or the whole body makes the pilgrimage around and around Borobodur to the top

132 (top right)
Only the eyes move through the patterns of a Moorish tile

133
The body and the eyes are given conflicting cues in St. Peter's Piazza

134
A path can be a stretched out plaza, like the one in front of La Parroquia in Guanajuato

Bernini's forecourt for St. Peter's in Rome. (133) Here the eye sees one thing (a certain grand intimacy) while the feet feel another (unexpectedly great distances). St. Peter's forecourt is an extraordinarily sophisticated example of visual cues (given by the receding side colonnades and by the statues, which are larger near the facade of the cathedral than near the main elliptical space) counterpointing haptic cues (which reveal how far away the facade is). This is much more than a perspectival trick to make the facade seem closer; it pits one sense against another for a powerfully unsettling experience.

Almost too obvious to note, but too often ignored, is the special nature of a path as a void ready to receive human movement. Being a void, it depends on and unites the surfaces that front on it, rather than suppressing or dividing them. The real-estate developer, or his public counterpart too often regards his negotiable pieces of real estate with their precisely described boundaries as the real thing and the paths between them as nonexistent; but it is those paths that give much of the value to his place.

One kind of path is created by an elongated plaza, whose opposite sides are more closely related than its adjacent ones. (134) The path itself may be savored through the time it takes to move along it, though the whole plaza is still visibly a place. A more prevalent kind of architectural path is of course the street, edged perhaps on one or both sides by continuous buildings (135, 136) or flanked

135
More prevalently a path is a street, with buildings perhaps on one side, like the Rue de Rivoli

136
Or buildings lining both sides

137 (bottom)
Or buildings intermittently along the sides of the street

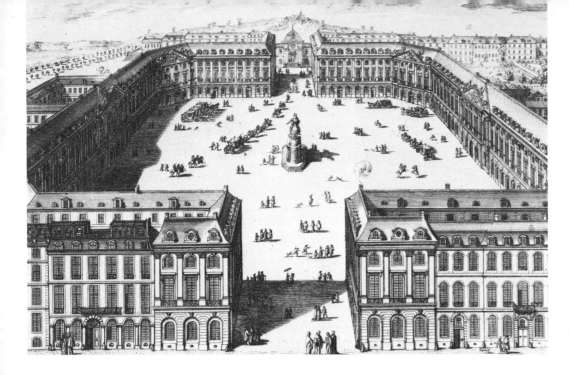

by free-standing structures with spaces in between. (137) On some memorable streets, a marker can intervene without stopping movement along the path, as in the Place Vendôme in Paris. (138) Or the vertical dimension can be the predominant one, and motion along the path can be via ramp or stairs or even a visible elevator. (139)

A vivid instance of an important path is the pilgrimage route, where following the path itself constitutes a crucial part of the ritual. The circumambulation of Borobodur in Java, for instance, or the climb on one's knees up the steps to the shrine in Braga, Portugal, (140) offer highly structured versions of such a path.

Since a path implies movement, the form of locomotion is important. Pedestrian movement, for instance, which has traditionally been the activator of path is marvelously flexible, allowing (for most people) turns of any dimension or degree and encompassing a wide variety of speeds up to about four miles an hour. A bicycle or animal-drawn vehicle extends the range of possible speeds, at the expense of directional flexibility. And the automobile offers us higher speeds and more kinetic delights but at the expense of hardening the first boundary out from the body and reducing our contact with the world around. (It introduces too the even more perplexing puzzle of storage, which puts a staggering demand on most places. Even snails must long ago have noted that being accompanied by a large inelastic extension of the body boundary can be a damned nuisance.)

138
On some streets, a marker intervenes without stopping movement, as in the Place Vendôme

139
Or the path can be vertical, as in the Bradbury Building in Los Angeles

140 (*opposite*)
The climb up a pilgrimage path in Braga is ritually structured

Pattern

Patterns are composed mostly of paths and places, but it is the system by which they are related that allows us to make sense of a bounded space. The usual kinds of patterns can be classified as haptic, haptic with geometric, centripetal radial, centrifugal radial, the grid, and lately the three-dimensional grid.

Haptic patterns are composed of piece-by-piece responses to the situation at hand rather than being based on any kind of visual or conceptual grand design. Some writers have equated haptic patterns with ancient Greeks and others with modern Englishmen, but they show up in the plans of old towns everywhere, where circumstantial occurrences have had greater force than a predetermined order. The plan of the old city of Córdoba, Spain, for example, consists of large and complex residential blocks which once provided defensible housing for extended families. (141) There the concern for security produced a desire to keep exterior wall surfaces to a minimum. No particular geometric shape was of interest, since it would never have been seen anyway from the narrow pedestrian paths between the blocks.

Almost any Middle Eastern town plan serves as a splendid example of the haptic-with-geometric pattern. (142) The residential and commercial areas of the town are haptic, with streets running, the eye supposes, altogether irregularly and without recognizable pattern between the inhabited

blocks. The monumental religious sector of town, however, has a geometry of its own. A regular grid of columns in the mosque makes explicit the civilization's concept of a monumental order capable of establishing social as well as physical control of the site.

The collision between a haptic and a regularly geometric plan is particularly vivid in the northern Italian town of Vigevano, where a monumental Renaissance piazza was carved into the irregular pattern of a medieval town. (143) The clash of systems, which is not visible in the North African towns except in plan, is dramatically expressed at Vigevano in the facades of the regular square which give way surprisingly to the exigencies of the medieval streets behind.

In larger cities functional differences between major roads leading from the country to the heart of the town and minor roads serving individual neighborhoods create a radial system, which could have been made by cows, as they used to claim in Boston, (144) or, as in Karlsruhe, (145) by a princeling anxious to create a physical manifestation of the spread of his power.

The Greek planner Constantinos Doxiadis describes an apposite (though in most ways opposite) visual version of the centrist planning of Karlsruhe, which suggests that important Greek ceremonial sites were laid out *around* the human participant (who thus became central to the place) at the point where he crossed the threshold of the sacred precinct. Doxiadis cites two modes, the

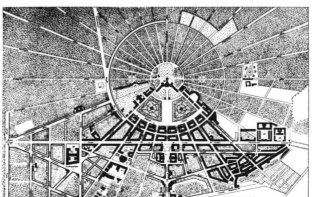

143
Vigevano: a regular Renaissance piazza carved into a medieval town

144
Boston: A radial system invented by cows

145
Karlsruhe: A radial system invented for an ambitious prince

97

0 10 50 100 150
metres

Doric and the Ionic, the former laid out in twelve 30° segments around the observer, with buildings, walls, and other objects to close in the view, except in the 30° segment straight ahead, which was left open to a distant view. The Ionic mode, as he describes it, was laid out in ten 36° segments, which located the corners or edges of built structures arranged completely to surround the observer, closing him off altogether from the world outside and creating for him at that point an inner space. (146)

The curious, unsettling sense of revelation such a radial spatial model contains underscores the extent of our acceptance of and dependence on the rectangular Cartesian grid. The grid is a powerfully ambiguous system, at once authoritarian (it can be imposed onto a piece of the earth's surface the designer has never even seen) and democratic (the pieces, within some bounds, are interchangeable and negotiable). It is orderly, very easy to describe, and altogether unmemorable ("was that 92d street or 93d?"). Washington, D.C., presents a complex and fascinating example of a radial plan imposed on a grid: Pierre L'Enfant's Baroque radial scheme, sensitively adjusted to the natural landscape, overlays the practical grid suggested by Thomas Jefferson. (147)

But long before Jefferson, in 1532, Puebla in Mexico had been laid out according to the laws of the Indies on a grid so widespread that four hundred years elapsed before the town reached its edges. (148) And as early as Hellenistic times the

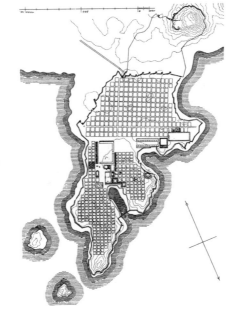

147 (top left)
Washington, D.C.: radial system over-laid on a grid

148 (top right)
Puebla: a grid laid out according to the laws of the Indies

149 (bottom left)
The Hellenistic city of Miletus had been laid out on a grid

150 (bottom right)
As was the whole state of Indiana

Greek city of Miletus was colonized upon a grid layout. (149) In Jefferson's era the grid was extended to organize entire proposed states in the Northwest Territory: Indiana especially retains the grid almost unchanged. (150) Later the grid was spread over some really implausible sites, such as the steep hills of San Francisco, where the very collision of system with circumstance has brought about some of the most memorable places in the

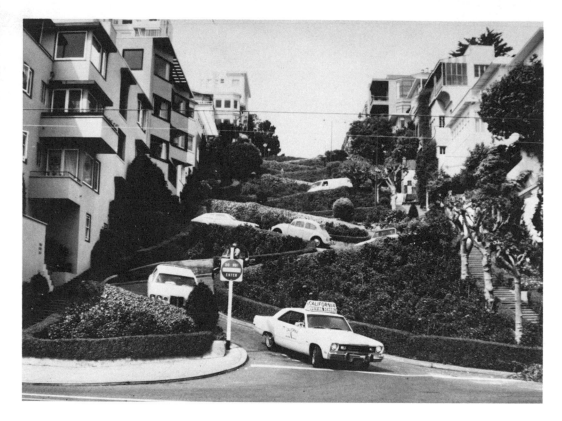

city: streets which suddenly give up on too steep a hill and become pathways, or Lombard Street, which makes a dozen tight loops to descend one block. (151)

Twentieth-century theoreticians have added a dimension to the organizing grid to aggrandize what they call an infrastructure into what they term megastructures, giant buildings which function as streets for the delivery of people, goods, and services in three-dimensional space frames. Yona Friedman, a French architect, has even dreamed of three-dimensional grids high above the ground in whose interstices are suspended buildings. (152)

Edge

The final aspects of the extended domain to consider are its edges, which wall it in, or face out from it. Especially notable elements of the edge are the facade, the parapet, the wall, the bay, and the fold in the system.

Facade can function, as in the city gate, to address expressively the larger realm, looking beyond the edge to the world outside. The Chateau Frontenac, (153) facing out over the Dufferin Terrace, serves as a facade for the city of Quebec, as does more simply a mission church in the Mexican state of Sonora, whose white stucco facade reminds us of a lady who has painted her face (or an ancient warrior who has painted his) to affect someone out front. (154)

Some of the most memorable architectural

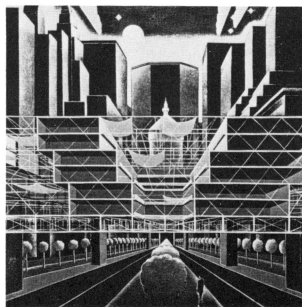

151
Lombard Street in San Francisco copes with the collision of hill and grid

152
In the twentieth century, architects such as Yona Friedman have proposed three-dimensional grids

100

153
The Chateau Frontenac serves as facade for Quebec

154
A mission church in Sonora, Mexico, has a white stucco face

155
Parisians face the Seine

156
Assisi faces out over its valley

edges in the world are terraces edged by a parapet so that they face out across water or out across space from high in the air. The upper end of Vézélay in Burgundy or the heights of Edinburgh or Quebec facing out across a valley, or the embankments of the Thames or the Seine (though not, alas, of the Hudson or the East River), or the parapeted edge of the Italian town of Assisi are all examples. (155, 156)

Walls, from the Great Wall of China on down, are normally less ambiguous than the parapet in their function of excluding a perhaps hostile outside, though sometimes a duality creeps in as a function of time: the walls of Marrakech in Morocco, for example, have served to defend the city, but they also serve in peaceful times as a backdrop for markets held *outside* them. (157) Here there is a spaciousness and a visibility not found within the labyrinthine town.

The qualities of edge are heightened at special coves, bays, or harbors ringed with facades. Thomas Jefferson's lawn at the University of Virginia, with continuous colonnades along its sides and a rotunda at its head, used to form a controlled space, complete in itself, which opened at one end out across a wide valley. (158) (The opening was stopped up in our century by a gymnasium.) Other examples are the crescents at Bath, England, with their curving facades fronting on a greensward that slopes down toward the river, (159) and John Nash's Crescent in London, which makes a bay off Regent's Park.

157
In Marrakech events which require much space happen outside the protective walls

158
Jefferson's buildings at the University of Virginia formed a bay open to the valley

159 (below)
The Crescents at Bath form bays off the wide space of the river valley

A final and special configuration is the fold in the system, the place where the pattern stutters to produce an edge. Some western American cities, most notably San Francisco, Denver, and Dallas, were laid out with grids of different orientation, presumably by rival surveyors, producing at the collision a street with bewildering intersections. (160–162) Perhaps because traffic snarled at these special streets, an edge was formed as surely as if a wall had been built. Energy collected here, and three of the most urbane business districts in the American West were formed.

This short lexicon of forms and locations reminds us that the world is rich in successful examples of the connection between our image of our own internal landscape and our recognition of it in the world outside. In the last chapter we will examine six places very different from one another which, we think, are successes, in order to consider further some of the conditions for arriving at this special sense of Place.

160 *(top left)*
Grids collide in San Francisco

161 *(top right)*
Or Denver

162 *(below)*
Or Dallas

9 Human Identity in Memorable Places

If architecture, the making of Places, is as we propose a matter of extending the inner landscape of human beings into the world in ways that are comprehensible, experiential, and inhabitable, and if the architectural world is rich in instances of this success, what then is so dramatically wrong with the way we build today? Why do people not like their houses and apartments? And why have we been guilty of desecrating or obliterating the landscape perfected by the hand of man? Why, that is, have the *insides* of our world, the places we make for our own inhabitation, which are defensible and free from the chaos or dangers outside, in our century become for many the hostile zone, while "in wilderness is the hope of the earth." And why is the only chance for the world thought to be for man to keep his hands off the pieces he has not yet destroyed?

What is missing from our dwellings today are the potential transactions between body, imagination, and environment. It is absurdly easy to build, and appallingly easy to build badly. Comfort is confused with the absence of sensation. The norm has become rooms maintained at a constant temperature without any verticality or outlook or sunshine or breeze or discernible source of heat or center or, alas, meaning. These homogeneous environments require little of us, and they give little in return besides the shelter of a cubical cocoon.

Buildings, we are certain, given enough *care*, are capable of repaying that care (an environmental instance of bread cast upon the waters coming back club sandwiches). We will care increasingly for our buildings if there is some meaningful order in them; if there are definite boundaries to contain our concerns; if we can actually *inhabit* them, their spaces, taking them as our own in satisfying ways; if we can establish connections in them with what we know and believe and think; if we can share our occupancy with others, our family, our group, or our city; and, importantly, if there is some sense of human drama, of transport, of tension, or of colli-

163
*Once a single perspective could describe
the intentions of the designer*

sion of forces, so that the involvement endures.

The special, immaculate collision, in which building or landscape pieces come sharply up against one another without loss of their individual identities or spirit, is especially important in the making of memorable places. A classic example is the gridiron plan of San Francisco, which collides with steep hills in a balance which has not surrendered the identity of the hills, but indeed has strengthened their image in the welter of detailed arrangements of stairs, walls, tunnels, walks, and switchbacks which make the grid functional and more memorable than ever.

Architectural design becomes, in such an instance, a choreography of collision, which, like dance choreography, does not impair the inner vitality of its parts in the process of expressing a collective statement through them. Choreography, we believe, is a more useful term than composition, because of its much clearer implication of the human body and the body's inhabitation and experience of place. In another simpler time, perspective drawings taken from a single station-point could describe the visual intentions of the designer, and his other intentions were understood. (163) It seems significant in this connection, however, that the architectural works of Michelangelo, clearly meant to be experienced with all the body, were never all drawn in perspective in advance. Really, they couldn't have been. The experience of being in a place occurs in time, is far more than visual, and is generally as complex

as the image of it which stays in our memory.

To at least some extent every real place can be remembered, partly because it is unique, but partly because it has affected our bodies and generated enough associations to hold it in our personal worlds. And, of course, the real experience of it, from which the memory is carried away, lasts much longer than the camera's 1/125th of a second: perhaps the light plays upon it, and the shadows move; or breezes blow or the air is still; or perhaps the snow is falling, blurring the edges like memory blurs time itself. The designer of every successful place both wittingly and unwittingly was choreographing all of this. In addition he may have choreographed a collision between his desires and the constraints of budget, rules, and an unpredictable client, as well as the sun, rain, and perhaps the occasional shaking of the earth.

The real places on the earth, that is to say, are susceptible to continuous readings, which is to say many readings, which is almost certainly to say complex and ambiguous ones. It seems to be a characteristic of them, too, that they have extraordinary changeability, sometimes of use, almost certainly of size (as in the notion of the city as house, and the house as city): each can be seen as a potential toy, capable of being pocketed in the memory and carried away, or taken out to fill for a while the whole of one's conscious attention.

As a conclusion to this book, we set out to describe six places that we know, of varying sizes and use, in vastly different locations. Four are public places, to be shared by citizens, or students, or shoppers, or worshippers; two are houses, to be shared inside just by their inhabitants and guests. Two, immodestly enough, are structures in which one of the authors has had a hand. All six, we believe, meet the tests of memorability required of a Place; all facilitate the transaction between body, memory, and architecture which allows us to dwell in them in the fullest sense. The six we chose are the Athenian Acropolis; the village of Stonington, Connecticut; Kresge College at the University of California, Santa Cruz; the Winslow House in Chicago; the Wies Church in Bavaria; and the Burns House in Los Angeles. We hope a description of their differences, and their special attributes, will illuminate the qualities they hold in common.

The Acropolis at Athens

Of all the places in the world, this is the most likely to cause the Western visitor to go weak in the knees, for just about all the reasons that establish a special place. The connections to memories within Western culture, of course, are legion: this is where Pericles delivered his funeral oration, where art overcame politics and destroyed an empire, and where the decisions which launched and collapsed the golden beginnings of Western civilization were made. It would be hard not to thrill even if this were only a shapeless pile of rocks. But the Athenian Acropolis is one of the most carefully

and sophisticatedly shaped places on this planet, and its powers remain undiminished, even (maybe especially) in its ruined state. The Venetian explosions centuries ago did no more to its spirit than the loss of Venus de Milo's arms did to her.

To begin with, the site is magnificent. The triangular Attic plain, bounded on two sides by mountains and on the third by the sea, is huge but comprehensible and visible all at once. From it arise two outcroppings. Of the taller, Mt. Lykabettos, which is pointed on the top and now has a Byzantine shrine, no mention survives from classical times; the spot is bizarre, unsuited for habitation by a people of classical sensibilities. But the other outcropping, the Acropolis, is a perfect citadel: its flat top is big enough for human interaction, set apart from the city below and yet in command of it, strongly defensible against hostile outsiders, and just difficult enough of access to make the uphill path seem a very special event, a quest in fact. (164)

Almost 2,500 years after their erection, the hilltop buildings serve as models of sophisticated caring. Their columns, cut from marble, bulge just slightly, possibly suggesting to the human observer the feeling in his own muscles that he knows from holding aloft a burden. The capitals bulge, too, to demonstrate the cushioning they provide for the heavy entablature above. The sympathetic maidens carrying their porch render the supportive role of the columns and their capitals even less abstract. (165) The columns on the Par-

thenon lean slightly inward, as people would, to enhance the sense of stability of the whole building. (166) And both base and entablature swell slightly to counter an optical illusion that would make a straight line seem to sag. The sculpture above, too, was made to be seen from ground level and not from an abstract and unreachable vantage point straight ahead of it. On the gate building, the Propylaea, openings are carefully placed to *seem* to be centered in the spaces between the columns to a person ascending the hill. (167)

The delicate temple of Nike Apteros rises to the right of the steps seeming in its Ionic lightness almost to float above the entrance. But it is at the Propylaea that the magic moment comes, the place of arrival that rewards the body's exertions and fills

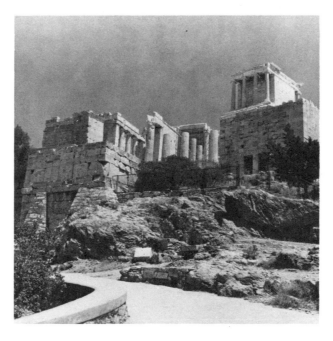

164 (opposite)
The Athenian Acropolis is a perfect citadel

165
The Caryatids on the Erechtheion span from earth to sky

166
As do their more abstract equivalent, the columns on the Parthenon

167 (bottom)
At the Propylaea the whole scene comes together

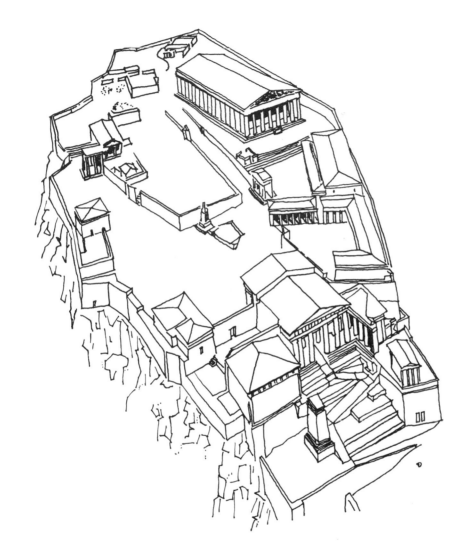

us with wonder: there, ahead and to the right, as close as it could be without losing the sense of its perfect wholeness, is Athena's temple. After all these centuries it is still the closest mankind has come to a building which unites the human body and the divine. To the left, fuller of the circumstantial and the complex, is the Erechtheion, from whose porch the stone maidens carrying its roof step serenely into our space.

It did not look like this 2,400 years ago: the Parthenon was painted, in part, bright colors. So was the sculpture, and the steps were crowded with votive tablets. Probably there was a wall which would have hidden the lower part of the Parthenon from the vantage point of the Propylaea. But there has always been an order to it, something that makes it clear that those buildings are in the right places, places that respond to a human sense of order that proceeds from the body and must, therefore, have been there from the beginning. (168) The method of laying out this hilltop proposed by Constantinos Doxiadis (see 146) is convincing, not only because it seems to tally with the facts, but because it seems such an eminently sensible way to lay out a special space that must be entered from a particular point. From there ("A" in the Propylaea), as we discussed in the preceding chapter, radial lines 30° apart intersect the points where the corners of all buildings fall, so that the buildings, seen in varying perspective, complete a built enclosure *from that point*. As soon as the observer moves, of course, the enclosure

168
Though in the time of Pericles it came together in a different and more complex way

110

shatters, and the long views of the Attic plain reappear.

The shattering manifests the collision between forces that animate this vital place. The collision of the Parthenon, all perfection, and of the complex and ambiguous Erechtheion sanctifying a number of disparate shrines, is evident too, and the collision between the rugged site and the internally ordered temples is basic to the place. One can imagine all too many twentieth-century architects, faced with this site, simplifying their task by having the hilltop laid flat. Not so Phidias and his colleagues, who must strongly have felt the genius of the place and its power when they laid their works against it.

Stonington

The borough of Stonington, Connecticut, does not have the transcendent importance to Western civilization that the Athenian Acropolis does. But to residents and visitors along the Connecticut shore, it is remembered with fondness as a very special Place. Fortuitously isolated from the surrounding region by its peninsular location and the slice of some railroad tracks, Stonington has succeeded in preserving its rich resource of eighteenth- and nineteenth-century buildings. The sense of isolation from the rest of the world, both in time and geographic place, is vital to the memorability of this village. Yet it is a complex set of patterns and events, both designed and natural,

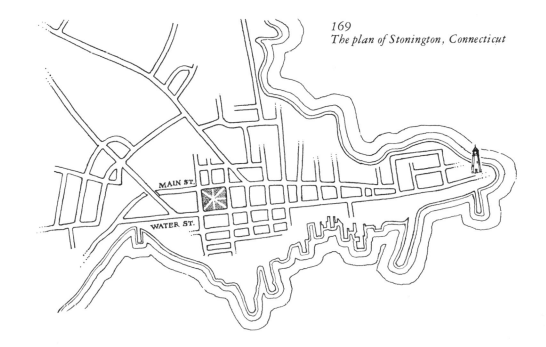

169
The plan of Stonington, Connecticut

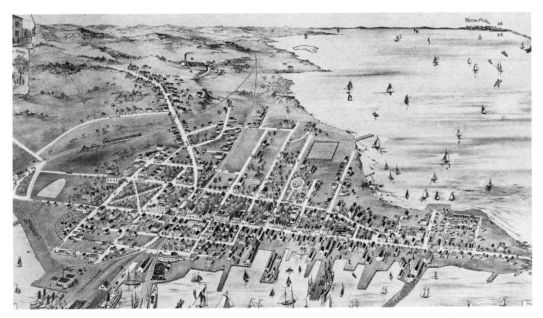

111

170
The lighthouse marks one end of the
major pedestrian axis

which contributes to the specialness of the place.

The primary access to Stonington slips into the peninsula and intersects the street grid on a diagonal. (169) In the town itself the grid is a small but insistent orthogonal network. Only two streets define the principal north–south axis, but they are pinned down and marked by a park at the beginning of the peninsula and a lighthouse and "the Point" at the end. (170) Stretched between these two foci, Water Street serves as the main commercial artery and Main Street as the most formal residential path; the two work in concert as the primary pedestrian promenade. This may be an early antecedent to the developer's gospel of the 1960s that major "magnets" should always be located at either end of a commercial mall. Significantly, this path, from which one can experience virtually all the edges of the town, is small and discrete enough to be comprehensible, yet spatially and visually complex enough to hold our interest as it unfolds itself in time and movement. It is particularly satisfying both to the visitor and the resident that the town can be walked in twenty to thirty minutes and yet, because of the complex and changing vistas of the sea and shoreline, it can never be fully known.

The peninsula crests on a line approximately defined by the Main Street/Water Street circuit so that all streets slide down toward the water, affording easy views and comfortable movement to the shore. The regular street grid is in gentle juxtaposition to the highly irregular shoreline, so that a

manmade formality and clarity plays off against a complexity that comes from a rocky shore. This contributes to the sense of inside versus outside that pervades movement through the town. The houses on the central streets are the most formal, rigorously geometric, and urbane structures in town. (171) As one looks or moves toward the water, they become more differentiated and informal. (172) They now respond simultaneously to the proper public paths on their front facades and to the private, casual experience of the water on the back.

In Stonington the sense of a common contract to establish a public realm is most apparently expressed in the boundary conditions; gates, fences, and front lawns where space permits are carefully

171
The most formal houses are on the main streets

172
And more informal houses are near the water

considered, impeccably maintained, and constructed so that the embellishments of individual houses have a harmonious relationship to the whole. (173) While restrained and mutually coordinated, these public gestures are as highly energized by the care of their makers as are the more private gestures of the porches which look to the sea. Here front and back are equally important, but different, as they respond to the special conditions of their surrounds.

Many of the memorable qualities of Stonington are enhanced by its being a small and discrete piece of land. Consequently, it has only one center or heart, one main commercial street, one point, one lighthouse. This property of things being unique confers special importance on very modest places.

Kresge College

The Athenians had given great importance to the construction of their Acropolis. To build it they had used up the treasury of their allies which had been destined for armament. And they lost their war, though they gained immortality. Twentieth-century governments have generally not sought to emulate the Athenians, and Kresge College at the University of California, Santa Cruz, which next occupies us, is keynoted by modesty, not to say cheapness of construction. We include it because it was designed by one of the authors (Charles Moore, with William Turnbull), so the intentions behind the forms are especially accessible to us.

173
Gates establish boundaries while integrating separate building elements

114

The Santa Cruz campus of the University of California, newly established in the 1960s, occupies a magnificent site of coastal meadows backed by a redwood forest. The campus had originally been planned to accommodate 27,500 students; its chancellor, seeking intimacy in the face of such a number, decided to establish a series of separate residential colleges in the forest, each to serve perhaps 600 students, 350 of whom might live there, with common facilities, some classrooms, a library, dining hall, and faculty residences included in the college. Science classrooms, main library, gymnasium, auditoriums, and the like, are centralized.

Kresge is the sixth of the colleges to be built. It occupies an ascending ridge, through an area of second-growth but already majestic redwoods, with a few fine fir, bay, and madrone trees visible in the flanking valleys. (174) The trees were important to chancellor, students, and architects, and very few had to be cut. They provided, in their intricacy, one of the most compelling opportunities for a collision of need (for enclosed space to live in) and circumstance (there was not much room between the trees). Another area of impact lay between the expectations of a university college, generally seen as an (expensive) institutional structure, with more modest dependencies for living quarters, and the budget, which was based on the colleges being in genuine competition with the cheap developer's housing for students which was springing up near the campus. This meant follow-

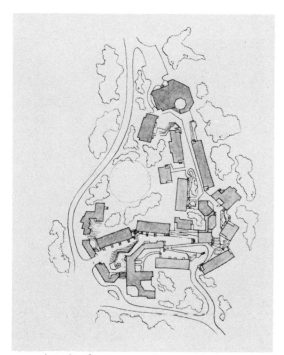

ing the same kind of construction as theirs: two-story, wood-frame apartments, stuccoed.

Yet another concern was the loneliness of the forest. The architects felt that a residence for undergraduate students should promote a feeling of community as well as an awareness of self. The model adopted to gain this end was that of the shopping center, which puts the crowd gatherers (the department store and supermarket, or here the dining and assembly quarters and the faculty and college offices) at opposite ends, and the places which would benefit from exposure (the small shops, or here the students' rooms and apartments) on the path between.

The scheme, then, was based on a pedestrian street winding up the ridge in the forest tightly

174
The plan of Kresge College

175
Students move through planar walls reminiscent of stage flats

176
The trivial monuments (1 through 9) and the gallery openings (abcd) mark syncopated cadences up the street

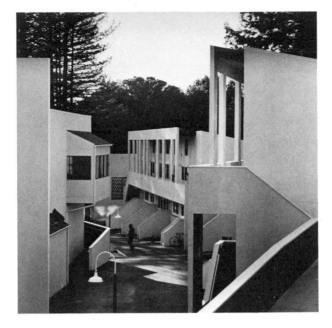

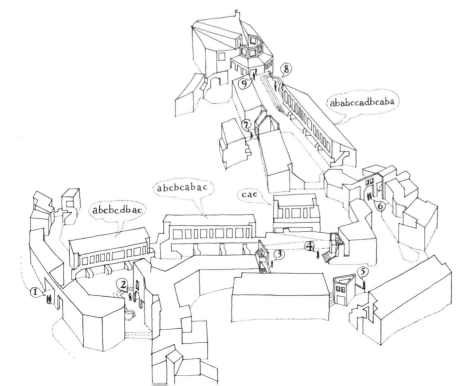

ababccadbcaba

abcbcabac

cac

abcbcdbac

flanked by buildings, their fronts painted white to bring light into this passage in the dark forest. (The other sides of the buildings, facing the forest, are painted a dark ochre, so as to merge into the trees.) The imagery of whitewalled galleries along a winding street is, of course, of a village, and the intimacy of a village is a useful model. But this is only a partial metaphor here; there is no mayor, no rich and poor, no overt hierarchy of power. There are, instead, aspects of make-believe, or an urgently important four-year-long operetta. (A reviewer delighted the architects by thinking he had wandered into a Sicilian production of "The Student Prince.")[43] The choreographic possibilities of such a vision fascinated the architects, and they fashioned the white gallery walls, which they painted bright colors on their reverse sides, into cut-out planes, like stage flats, adding other cut-out walls so that people walking in the street, especially conscious of their own bodies moving *through* planes, would feel themselves important, like dancers on a stage. (175) (That happens, to a remarkable extent, and to the objection of some.) The buildings are carefully and consciously stage sets, for a drama improvised by the inhabitants. An exciting moment for the architects came one Halloween, when at twilight jack-o'-lanterns appeared along the gallery rails and white-sheeted figures wailed ghostly sounds as they danced up the street.

The street is a long one, and needed landmarks to be comprehensible. Since the college is not a

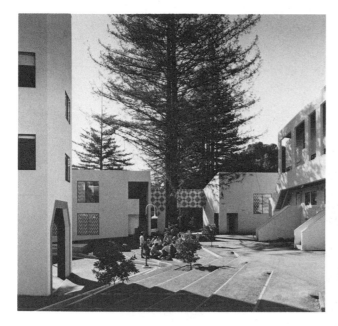

village, institutional landmarks would not do. And the students who were helping plan the college would not accept them anyway. They, in the best Judaeo-Christian tradition, would not allow the public rooms to be designated, until use had given them proper names. So the architects devised a series of what they call trivial monuments, which do not bear any hierarchical onus. (176) There is an entrance gate at the lower end of the street, a fountain, bright paint over the outdoor post office, a mock-monumental entrance to the laundry, a speaker's rostrum painted red, white, and blue with a garbage collection room beneath, telephone booths joined with a rainbow, the lopsided triumphal arch beside the library, and, finally, a yellow-lined rotunda at the top of the street,

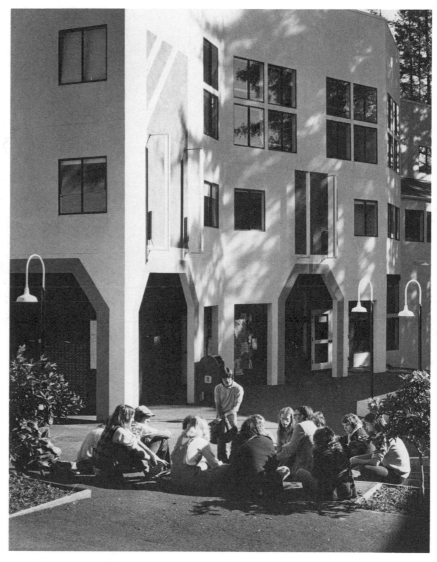

177
Entrance gate at the lower end of the college announces the street

178
A red rectangle marks the open post office

117

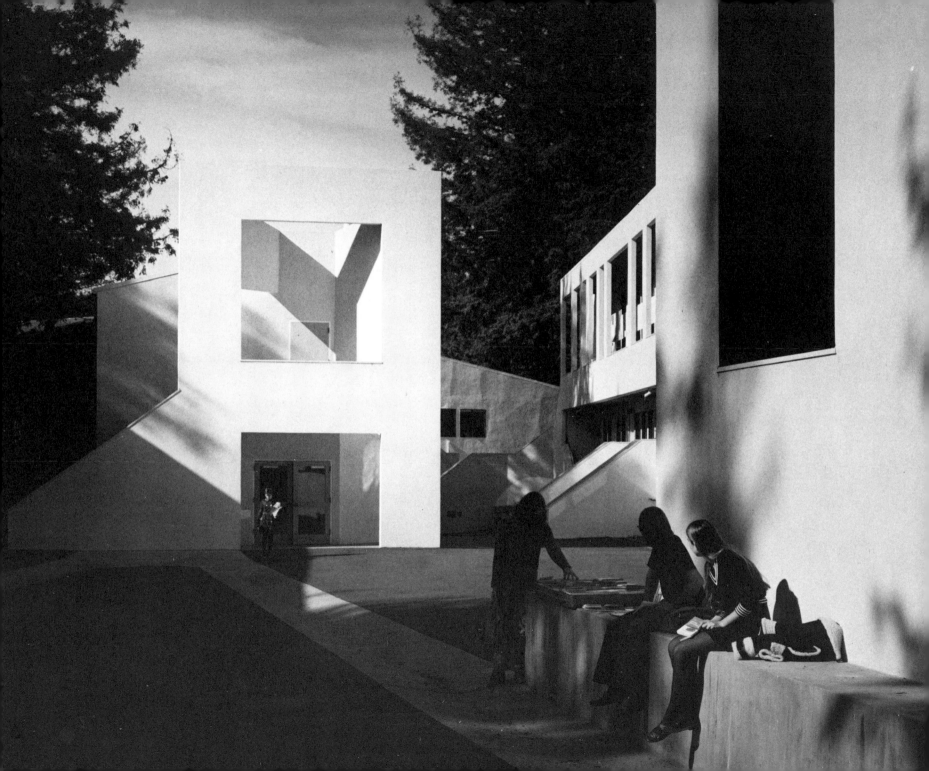

which serves as forecourt to the restaurant. (177–181) These are meant, without prejudicing the freedom of students to make their own new institutions, to signal to them where they are.

Many of the qualities which have given continuing life to the Acropolis are, of course, not here. There are no pure geometric forms like the Parthenon, no fine craftsmanship as on the Erechtheion. Kresge College is not a sacred place, but rather an extension of familiar, ordinary places. Here the buildings, like stage sets, can support the action of human bodies and encourage the strengthening of fantasy in human experience. House form, face, even columns, are not present; the signs they might have carried have been abstracted into the (affordable) simplicities of stucco walls. On the other hand, one might see the well-loved redwood trees as the columns; that would have been offensive to Socrates, who had declared his independence of the trees in the field, but to a generation whose views about inside and out are far more ambiguous and complex, the trees are part of the place.

Winslow House

The comments of the public can be devastating even to the most self-assured new homeowner. William Herman Winslow found it necessary to avoid the rush-hour trains between suburban River Forest and Chicago's Loop for several weeks to escape the taunts of his fellow commuters.

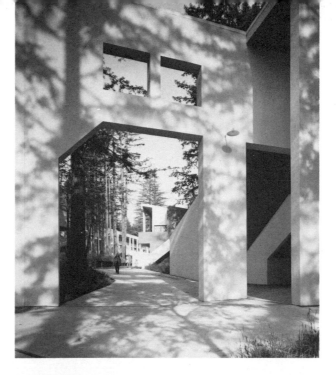

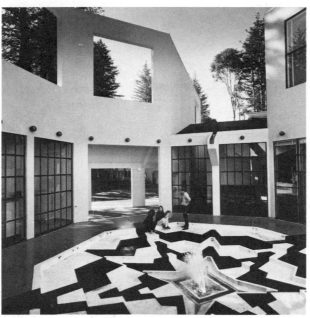

179 (opposite)
A mock-monumental entrance celebrates the laundry

180
A triumphal arch heralds the library

181
A rotunda at the top of the street provides space for outdoor dining

119

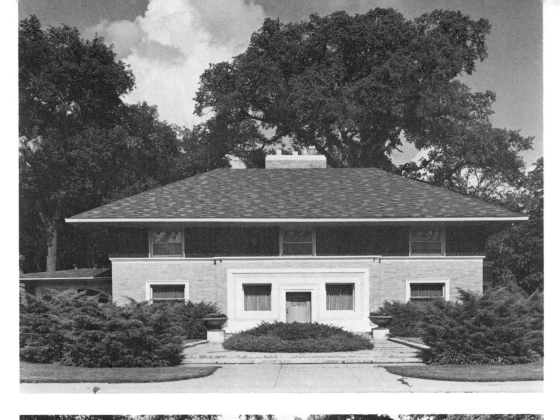

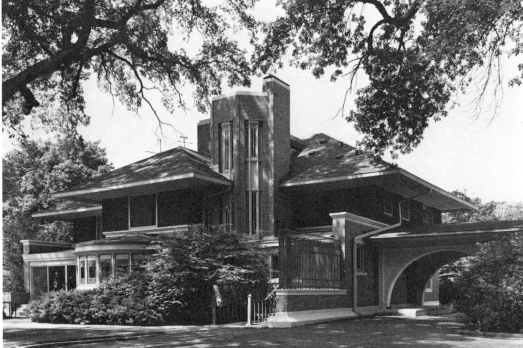

Winslow was the first client of Frank Lloyd Wright's independent practice. Whether he recognized the young man's genius, or was simply hoping to receive an extra measure of effort from a level-headed beginning architect, we do not know. But the Winslow House was a product of genius — the first bloom of the Prairie School.

Today it is difficult for us to see what aroused Herman Winslow's neighbors, for the building stands with graceful timelessness, seemingly as simple and straightforward as a child's drawing of home. (182) This was, however, Wright's first opportunity to express and execute fully his search for the elemental nature of the single-family house, and there are many more domains expressed than are at first apparent, which we relate to a psychophysical coordinate system.

The formal face presented to the street is quite different from the asymmetries of the rear. (183) Nathaniel Hawthorne noted "the greater picturesqueness and reality of backyards . . . as com-

pared with the front which is always fitted up for the public eye." The house and grounds are organized in a continuous progression from public formality to the more informal family-oriented activities of the backyard.

The vertical dimension is layered in homage to a social hierachy. Work and mechanical spaces, including Winslow's carpentry shop, printing press, and darkroom, were relegated to the basement. The ground floor is the public and family realm. The second contains rooms for individuals. And the attic tucked up under the roof was for a servant and storage, which Wright's later principles found something of an embarrassment.

The plans reveal values given to right and left. (184) Service and work functions, such as the library/office, stairs, kitchen, and bath — even the portecochere and stables — are placed to the left-hand side of the central axis. The right is reserved for the pursuits of leisure. And, in the middle, on axis, is the ritual hearth, the core of the house, about which the institution of the family is celebrated with an almost mystical reverence. (185)

The house has a tremendous presence, an impression due in no small part to the treatment of the site itself. A step up at the sidewalk makes a low podium of the front yard and sets it apart from the neighborhood. This setting apart, used often here, is described by Mircea Eliade as a characteristic of sacred precincts. The formality of this public landscape is enhanced by the rigid symmetry of the walkway and domesticated plantings. Here nature

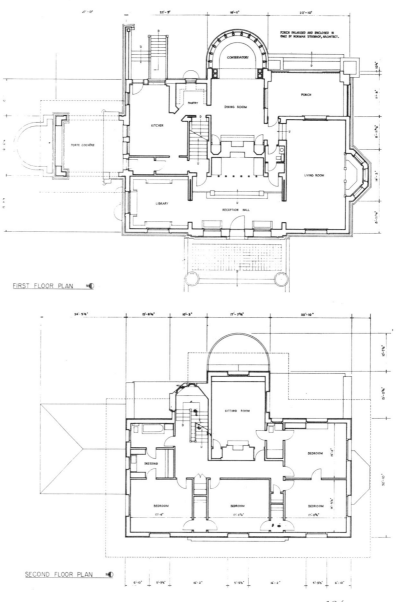

FIRST FLOOR PLAN

SECOND FLOOR PLAN

184
Winslow House plans reveal values given to right and left

conforms to the world of man while at the side of the house, planting slips into looser geometries in preparation for the expansive tree-spotted lawn in the rear.

The public face of the house appears to rest on a broad solid base of buff limestone from which rises a tough protective skin of golden brick. (As with many of Wright's works, appearances have little to do with the way things are actually put togehter, with no harm to anything but the master's philosophy.) It is topped by another horizontal band of stone. Above that lies the private family realm of the house, jacketed behind a band of molded chocolate-brown plaster. Here, above the reach of outsiders and sheltered from nature by the broad protective canopy of the roof, openings are sliced thinly into this delicate surface of manmade shadow. Below, the act of penetrating the brick skin is celebrated by edging the window openings in white stone. This practice only extends half the length of the side elevations before being discontinued. On the portecochere too, penetration through the facade is announced by an elaborately carved frontispiece of white stone unmatched on the rear. The front door, however, is the most important event on the facade. It is a decorated stone mask: a miniature face with eyes and a mouth, pushed forward slightly from the main block of the house, flanked by symmetrically placed urns, and resting atop a second low platform of aggrandizing steps. It is difficult indeed to imagine a more emphatic "front door."

Once through it, the visitor finds himself in the most formal and symmetrical room of the house. Ahead, up a few steps, flanked by the low rails, through an elaborately carved arcade, lies the heart of the house — the inglenook and hearth. It gives the impression of a sacramental altar. Here, above the fireplace, the family portraits were hung.

Although the stair to the upper floors is just to the left of the inglenook, it is hidden by a door, symmetrically matched by a closet on the other side. Access to the family realm is restricted.

The visitor probably got no farther than Mr. Winslow's library, or the living room with its central bay which served as a stage for the family's frequent musical events. This region in the house is the family's complement to the visitor-oriented entryhall — a place for formal family gatherings around the table near the hearth. (The parents' sitting room on the floor above enjoys a similar function and relationship in the realm of the individual and family life of the second floor.) The dining room ends in a large tentlike bay lined with stained-glass windows which at once focuses the space back upon the hearth and expands the back wall of the house outward to lay claim to the private landscape beyond. (186)

The rear facade is opposite in character to the front. It is a restless collision of projections, oddly shaped volumes, and carved hollows seemingly formed by circumstance. The area behind the kitchen is devoted to waste disposal and service access.

Later in his career Wright developed many of

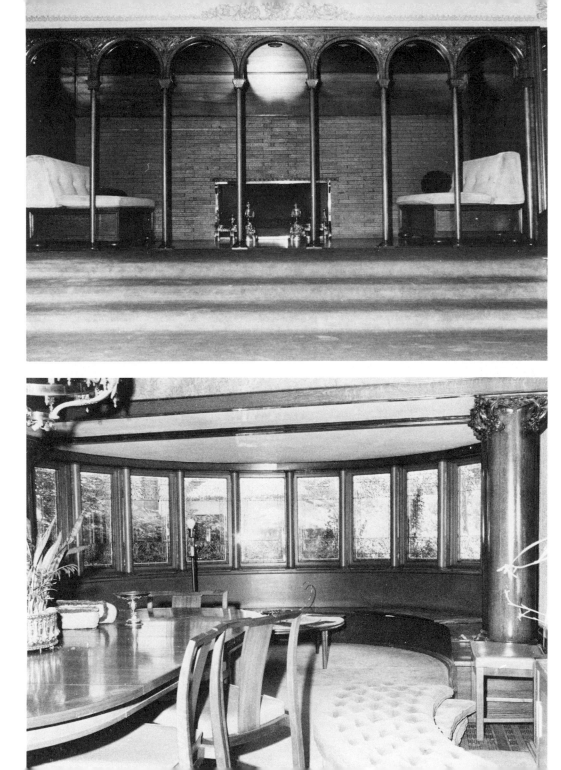

185
The Winslow hearth

186
The dining room ends in a large tentlike bay

123

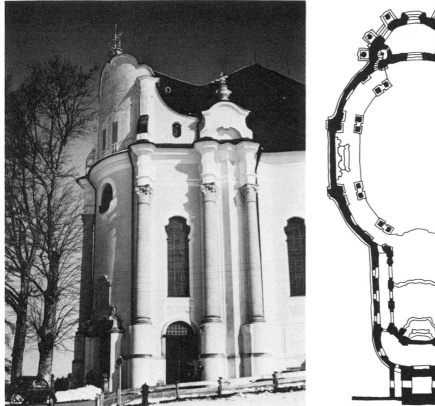

the ideas first seen here. The vertical layering and horizontal processions of his Prairie houses were strengthened through the use of his Prairie basement — a ground floor devoted to the realities of living. Formal spaces were axially grouped about the hearth, strengthened and enriched through the increasingly elaborate ordering of three-dimensional grids and the patterns and decorative properties of his materials. But the Winslow House was the first step — an undeniably memorable place. As Daniel Burnham admiringly described it, "A gentleman's house from grade to coping." It seems to us a powerfully clear statement of a house based on spatial forms of human identity: a sound and well-understood base of a brilliant revolutionary career.

Wies

Even with an understanding of the unique sense of space generated from the human body, the act of inhabiting, of dwelling on the earth, is complex and difficult, and from the beginning of recorded time mankind has enlisted allies in inhabitation. We tend our gardens not just to harvest food, but to extend our realms — the places and things we *care* for. Another more elusive ally is light itself. "The sun never knew how wonderful it was," Louis Kahn used to say, "until it shone on the wall of a building." Some buildings, Wies for one, are inhabited by light as well as by people.

This church in the meadow (die Wies) in a

187
The exterior of die Wies

188
The plan of die Wies

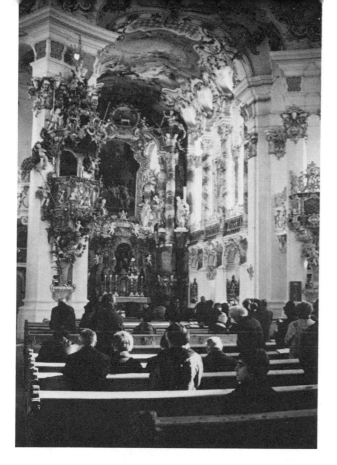

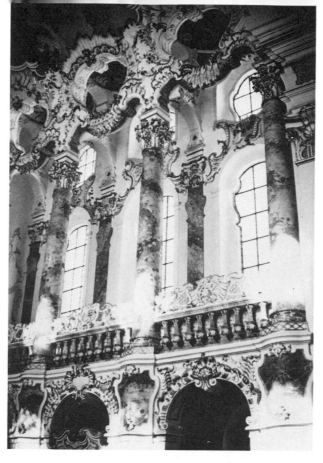

corner of southern Germany is one of the truly magical places in the world, and it is brought alive by light. (187) Its plan recalls the body of Christ, from the column-flanked triumphal arch at His feet to the golden mysteries of the sanctuary at His head. (188) People enter through the narthex and worship in the symmetrical body of the church. (189) But this is not the solid ground-based body of, for instance, Wright's Winslow House; it is a transubstantiation, dissolving solid into dazzling light.

It was made, in the eighteenth century, by a celebrated architect/craftsman, Dominikus Zimmermann, whose medium was stucco, and his forms are true to that marvelously yielding material, so different from obdurate stone. The basic scheme is a simple one, a double shell. The outer shell is solid wall, pierced by large windows. The inner one in the nave is a pavilion, held aloft on light pairs of columns, like a complex aedicula, or an inward-facing set of porches sent spinning. (190) In the sanctuary the inner wall is made of

189
Worshippers in the symmetrical body of the church

190
Inner and outer shells

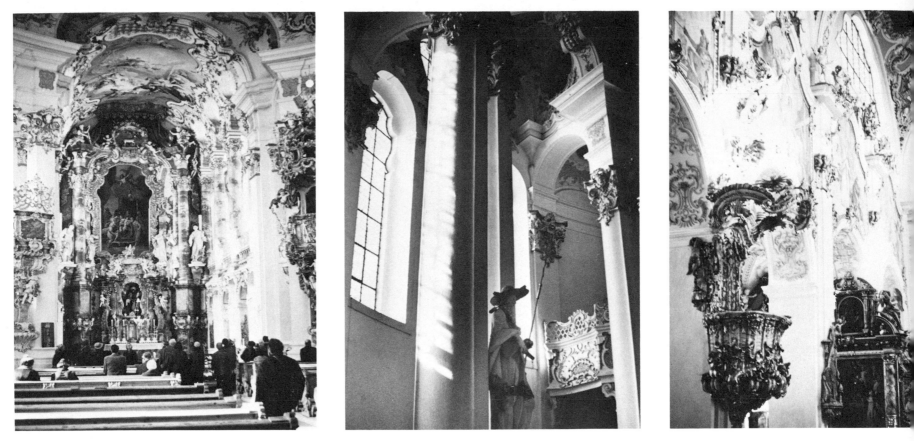

191
The sanctuary

192
Sun comes through the south windows

193
And shines on the north wall

columns piled on piers, holding aloft a swirling tracery. (191) The sunlight comes in the south windows, (192) backlights the south column pairs, and shines on the north wall behind, where the bright rays meld with the cool light coming through the north windows, perhaps reflected off the snowy meadow. (193)

As the sun's rays travel during an hour-long service, they catch the white and gold intricacies of the stucco, pinpointing, highlighting, and then leaving in shadow the heads and bodies of saints, the swell of moldings, and the golden tangles of garlands. But perhaps the most arresting objects in the light are the columns themselves, not round but swept out in a fillet where shadow becomes light, so that a sharp edge of darkness lines the shadow, or a glowing line marks the edge of the light.

Light animates the worshippers too, wrapping everyone in the bright evanescent warmth and

separating them from the mysteries of the dark polychromy of the altar. Here then is a complete experience for the celebrant in a baroque theater of the sun.

Burns House

Our sixth place, the Leland Burns house in Santa Monica, California, (194) may seem at first an unlikely choice: though it was designed in full homage to our concerns with body imagery (by Charles Moore, with Richard Chylinski), it has, mostly because of its site, none of the apparent frontal house-body imagery about which we have written and of which Frank Lloyd Wright's Winslow House is such a powerful example. Here instead the body imagery is interior, a matter of positioning landmarks in a private inner world in which people move and seem to feel especially relaxed.

The house is located on the side of a heavily populated canyon and approached downhill on a narrow, intimate side street. The land for the house was minimal; indeed the perimeter walls of the required living space are practically coincident with the legal boundaries. Outside there is no face. The house is entered from an alley, past blank walls and garages, through a wooden gate in the wall, marked by an ancient wisteria vine intertwined with a tangle of bougainvillea. (195) Then a quick turn leads to the carved front door, which gives, to the left, onto the head of the house,

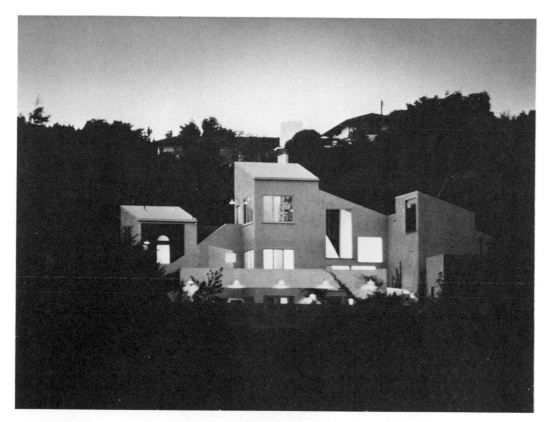

194
The Leland Burns House from across the canyon

195
The front gate

127

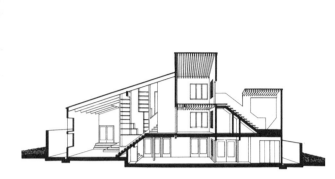

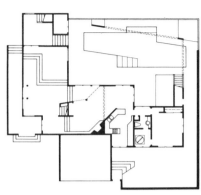

and straight ahead and down a few steps to the intimate heart of the house in front of the fireplace, and out next to the pool terrace. (196–198) Close by the front entrance the stair tower, a dark and interesting volume inside the bright volume of the house, leads up past the master bedroom to the tower study.

Sunlight comes in through high and low openings on the south side of the house, toward the pool and patio, but more light envelops the house through a huge skylight on the north, with the white fireplace wall under it. As a result, the two-story stair, lined in books and nooks, all very dark like a Victorian study, is wrapped in light. (199) Its presence in the house is strongly felt, part spine (going up to the attic equivalent), part intestine winding up through the space under the ascending roof. Tucked beneath the stair, where it approaches the ground, is a sinuous, soft seating arrangement facing the fireplace (its softness suddenly belied by its pseudo-formal ending, meant to recall the stiff round seats of Edwardian hotel lobbies). (200, 201)

At the foot of the stairs, rather unaccountably, lies the room that has been described as the head of the house, quite different in character from the rest, thanks to its simple shape and dimmer light, though its surfaces are similar. The room is graced by the owner's prized pipe organ, which functions as a kind of symbol of brain, or alternatively as an inward-looking face. (202)

The collisions here are numerous: the spaces at

196
Section of the Burns House

197
Plans of the Burns House

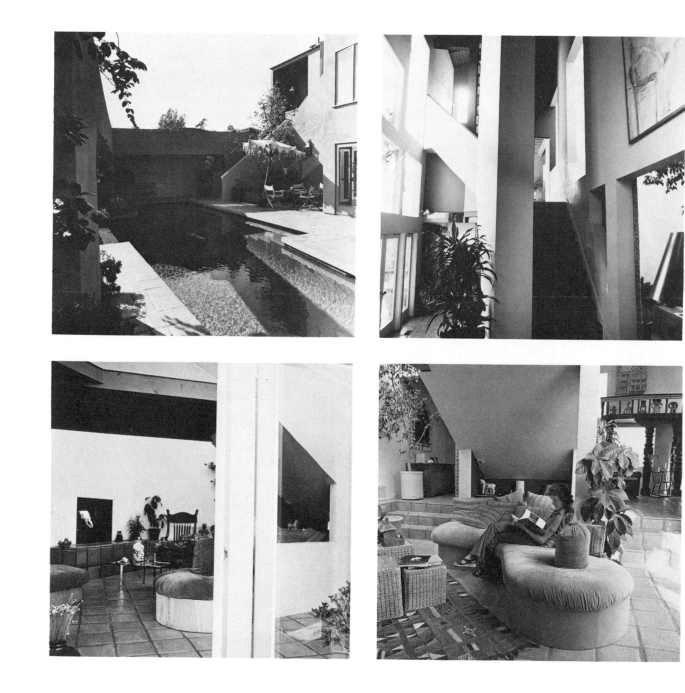

198 (top left)
The pool and patio

199 (top right)
The dark stair is wrapped in light

200 (bottom left)
Tucked under it, soft seats face the fireplace

201 (bottom right)
And end in a mock-formal circle

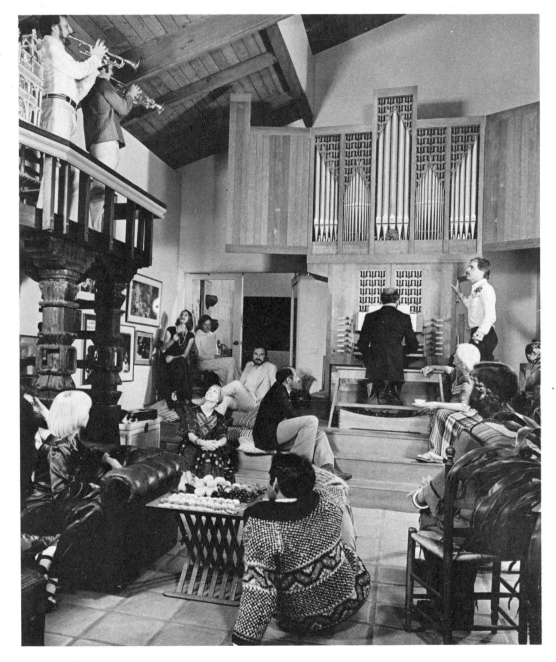

once flow together and strongly contrast; shapes and materials are familiar but rendered surprising by a kaleidoscope of twenty-eight exterior shades of orange, mauve, and ochre; and the stairway that so explicitly defines the vertical, lofty dimension is but a humble domestic plasterboard version of those proud marble maidens mediating between two realms in the sacred space of the Athenian Acropolis.

These six places, monumental and modest, important to all the world or to a smaller circle, attain their placehood in a variety of ways, but they have one powerful property in common: they are all *inhabitable* and they are all inhabited, either literally or in dreams and memories (as in the case of the Acropolis). They have received generous portions of human care and energy, and they return that investment. The transaction, the gift and the return, is not accurately measurable in cost and efficiency; it is much more truly seen as a donation of our vivid and sometimes mysterious human identity.

202
The organ serves as a kind of head of the house

130

Epilogue

The reader will have remembered that we promised an optimistic book and have made continuing optimistic assertions: first, that the landmarks and order of our bodies create a basis, comprehensible by everyone, for the extension of human identity into our environment; and second, that the world of architecture abounds in successful and even inspiring examples of that extension. Yet the reader may have noticed that among our examples of at least partial success there are, for instance, no contemporary apartment buildings. A survey of any city in the world (as far as we know) would produce a discouraging affirmation that, however wonderful individual dwellings may be, there are no schemes for multifamily housing or large-scale urban reconstruction that satisfy all the senses of the body and nurture the memory as well.

The rising protest against modern architecture's failure to deliver strong feelings of community and space has included the accusation that architects have been transmitting their message in a private code meaningless to most of the inhabitants of their buildings. The accusation is probably accurate, but the problem is more important than the delivery of messages, the horizontal activity of which Rudolf von Laban spoke and to which we have in these pages sometimes alluded. The missing links, we submit, are the vertical ones, which connect our bodies with earth and sky and allow us to feel "centered" and in place and therefore able to relate effectively to other people. From this comes the operationally revolutionary part of our thesis: that the large architectural office which serves the aggregate corporate client and regards problems of human inhabitation as problems of organization cannot address the concerns we are addressing. The huge architectural firm turning out undifferentiated urban cells for social masses is not going to make inhabitable dwellings just by getting elements of the visual codes' right. To help people inhabit the world, we feel, the basic act is not organizing but *caring;* the architect's client is not

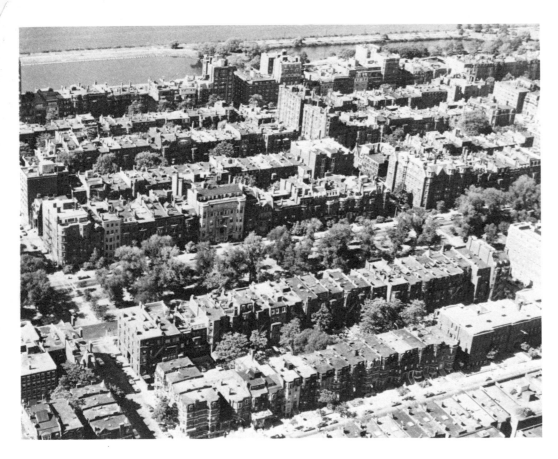

203
Back Bay Boston from the John Hancock Building

(however lightly) a cloud of iron filings across a surface.

Curiously, the wholesale inhuman "social" manipulation of urban form by twentieth-century architectural and planning offices has put a disproportionate emphasis on originality, on the unique. Rather, we believe, the design of the environment is a choreography of the familiar and the surprising, in which the familiar has the central role, and a major function of the surprising is to render the familiar afresh. The most satisfying places we know are not architectural zoos, but places like Boston's Back Bay, (203) or the canals of Amsterdam, or Georgian cities across the Western world, where a broad area of human agreement allows the merest nuance of difference to show up as an individual act of caring and establishes an urban scale against which civic acts of vigor and congenial daring might leap into the public memory.

It seems interesting to us to examine in this epilogue the possibilities for human agreement, even in our own time. Some hotels seem clearly to evidence it, to make Places where people know what they are doing together, what they share, as well as where and what they are as individuals at a special point on the surface of our planet.

In some other hotels and especially in some apartments, the shared realm does not develop, individual "centering" does not take place, and the task remaining for us is illuminated.

The Hotel del Coronado was built on the beach of Coronado Island in southern California in

undifferentiated society but caring individuals.

In the rhetoric of the past decades, the difficult act of dwelling, based on the act of caring, is elitist. It requires effort, and that sets some apart from others. The architects' proper role, it seems to us, is an accepting and absorbing one, to encourage others to make the effort and to develop the physical surrounds that make dwelling possible and attractive. But it is like a teacher reaching and moving a student, not like a magnet moving

1888. (204) It was one of the grandest of the exuberant resort hotels which in the late nineteenth century were springing up at places of special natural beauty across the country. The life-style of the inhabitants was well understood by all: it included the pleasures of the beach, the elegance of spacious bedrooms cooled by sea breezes, and the more formal splendors of the great ballroom and dining hall as well as the opportunity for rendezvous in smaller but still sumptuous parlors. The guest rooms were arranged on several floors around a great outdoor square, whose subtropical planting must have astonished travelers from the East and Mid-west just arriving on the new transcontinental railroad. Beside the open courtyard, enclosing one side of it, the soaring vertical spaces of the public rooms gave the visitor the chance to feel that he had arrived and was, in his body and all his senses, for the time being in a splendid yet personal house.

The Brown Palace Hotel in Denver is on an urban site. Here the special space that lets the spirits soar is indoors, at the center, bounded by balconies off of which the guest rooms open. (205) The weary traveler across the Great Plains or the Rockies cannot help feeling exalted on arrival at this interior. There are elegant but intimate dining and dancing rooms hidden from but near the center area, but they defer to the magnificent center, and the bedrooms themselves all open directly onto the balconies ringing the central space, so that the guests are oriented to and join in the

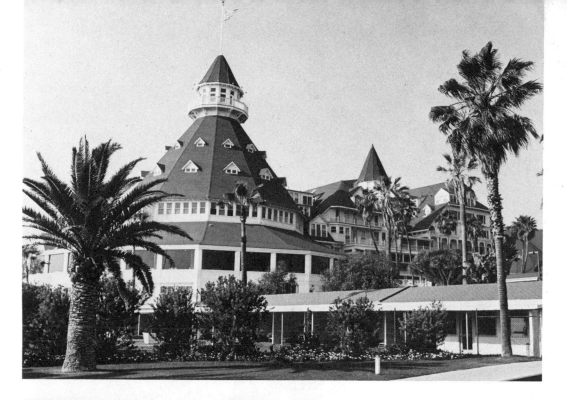

204
The Hotel del Coronado

205
The great space inside the Brown Palace Hotel in Denver

133

206
*The great space inside the Hyatt Regency
Hotel, Atlanta*

207
*Inside the Hyatt Regency Hotel at
O'Hare Airport*

continuous celebration of the upright body of the
building.

A series of hotels by John Portman of Atlanta
have made their debut in the late twentieth cen-
tury with some of the same tangible excitement
that had characterized their nineteenth-century
predecessors but that has since been submerged
under "economic necessity" and the spatial con-
striction of efficient air conditioning. The first of
them, the Hyatt Regency in Atlanta, is, we think,
the best: like the Brown Palace, it sports a central
space which clearly orients the temporary inhabi-
tant inward and upward and lets him know he has
arrived. (206) Guest rooms open onto balconies
which overlook the space, and festive elevators
move up and down the walls, animating the center

in both the vertical and horizontal dimensions.

Later came the Hyatt Regency at O'Hare Airport in Chicago, where a much larger, lower central space surrounds an elevator core, from which bridges on alternate floors span to the perimeter galleries onto which the rooms open. (207) The blockages in the central space tend to dissipate it, but much of the clarity is still present. The Atlanta hotel is on a city street, a part of the city. The O'Hare building has no such affiliation; it sits in a parking lot, occupying a whole world of its own, not connected to any larger community.

Portman's more recent Bonaventure Hotel in Los Angeles is located downtown, but even so it sits on a solid fortresslike base which seems designed to keep the city at bay. (208) Inside, the central solid which was small in O'Hare has grown fat and high, so what would have been the central space is now lower and forced into a ring around the expanded core. (209) There is still excitement for the eye as one looks up into complex structure and skylight; but the body's sense of importance at the center and of well-being, so exhilarating in Atlanta, is replaced by frustration, lack of orientation, even a kind of submerged panic at being unable to get one's bearings in the doughnut of space. The tensions which might give pleasure to the connoisseur regarding an etching of a Piranesi prison from an armchair here quickly give way to that same despair of ever arriving or leaving that might have afflicted a real inhabitant of Piranesi's magnificent polemics.

208
The Bonaventure Hotel, Los Angeles, from the street

209
The Bonaventure lobby

135

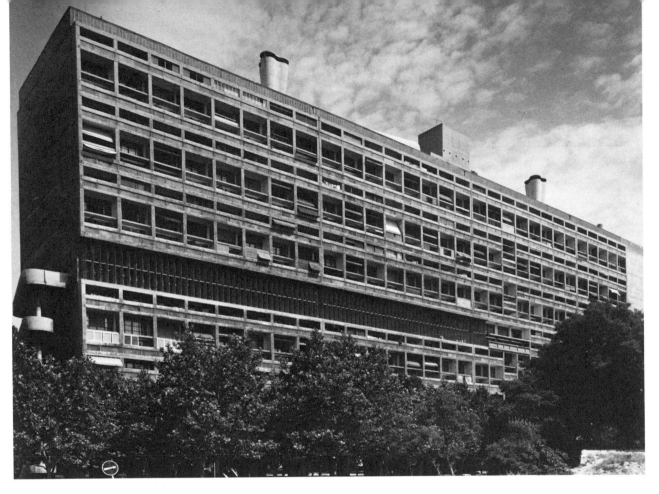

210
Le Corbusier's Maison Domino

211
Le Corbusier's Unité d'Habitation

The hotels we admire have the power of a shared realm with a human connection in which feelings of possession are shared by the entire constituency of the hotel, staff and guests alike. Apartment dwellers in our century have no such realm to share. The domains adjacent to the buildings, the piazza or the street, have been relegated to fast-moving cars, while the inner domains of attic and basement have, in the denser part of cities, surrendered to the "rational" limits of the multilayered apartment sandwich presaged by Le Corbusier's Maison Domino and further developed in his Unité d'Habitation in Marseilles. (210, 211) At the Unité the roof is shared, but there is no place more central and useful to share. The interior corridors that serve the apartments, however often architects may call them "interior streets," do not provide real spaces for human interaction. Indeed, the elevators and courtyards of these would-be streets have too often, especially in North America, pro-

vided opportunities for robbery and rape. Perhaps most notorious for this in the recent history of large-scale apartment blocks is the prize-winning Pruitt-Igoe housing project in St. Louis, which proved so dramatically unsuited to wholesome community development that the solution agreed upon in 1972 was dynamite. (212)

Habitat, a group of apartments built for Expo '67 in Montreal, was architect Moshe Safdie's careful and highly energized answer to the problem of alienation. (213) In a manner that has excited the enthusiasms of archtitecture students for decades before and since, Safdie piled up concrete boxes (as architecture students had been piling up cubes of sugar or styrofoam) in homage to the separate individual dwelling, to the celebration of mass production techniques, and to memories of the villages of Israel. But even Habitat, we submit, is only a *visual* solution. It lets you *see* differentiated dwellings, but it does not let you *feel* centered or

212
The solution to the problems of Pruitt-Igoe

213
Habitat in Montreal looks from a distance like individual dwellings

oriented or in place, and it establishes no relation to a larger whole that the community can inhabit.

The shared, ordered, and well-oriented realm the Royal Crescent at Bath so successfully represented two hundred years ago generally eludes us still. (214) It was, we must admit, built for an elite group who already shared an extensive area of agreement. Like most of the examples we have admiringly set before the reader throughout the book these dwellings were for people especially (even rather crazily) concerned with being in a special Place. We end with them because we believe that, like most of our examples, they express the intense personal concern of the people who built them and continue to care for them. The right to inhabit our landscape and to establish our identity is fundamental and not limited to any group; but with that right goes the responsibility to care. The caring and the energy for it depend on the sensitivity of the inhabitants, reinforced by professionals devoted to committing all their capacities to the task of understanding the potential of a place and the possibility of dwelling in it, of experiencing it with *all* the senses, of feeling it and remembering it and making it the center of a whole world.

214
The Royal Crescent at Bath

Endnotes

1 Gaston Bachelard, *The Poetics of Space,* trans. Maria Jolas (Boston: Beacon Press, 1964).

2 European visitors have noticed how special the American planning regulations are that link the dimensions of setback with the importance of the building. (Peter Smithson, English architect, seminar at the graduate school of design, Harvard University, fall 1975.

3 Edward T. Hall describes the cultural variations in this personal space in his books *The Silent Language* (Garden City, N.Y.: Doubleday & Co., 1959) and *The Hidden Dimension* (Garden City, N.Y.: Doubleday & Co., 1966).

4 Mircea Eliade, *The Myth of the Eternal Return,* trans. W. R. Trask (Princeton, N.J.: Princeton University Press, 1954), p. 22.

5 José Ortega y Gasset, *The Revolt of the Masses,* trans. anon. (New York: W. W. Norton, 1932), p. 164.

6 Sir John Summerson describes this evolution of form in his *Heavenly Mansions* (New York: W. W. Norton, 1963), chap. 1.

7 Susanne K. Langer's expression in *Feeling and Form* (New York: Charles Scribner's Sons, 1953), p. 95. "Architecture is an *ethnic domain* . . . A domain is not a 'thing' among other 'things'; it is the sphere of influence of a function, or functions; it may have physical effects on some geographic locality or it may not. . . . A ship, constantly changing its location, is none the less a self-contained place [domain], and so is a Gypsy camp. . . . Literally, we say the camp is *in* a place; culturally, it *is* a place." Thus an ethnic domain is a place with a particular organizing principle acting as the center of a virtual world.

8 Alexander Tzonis and Liane Lefaivre, "The Mechanical vs the Divine Body," *Journal of Architectural Education* 29, no. 1 (1975): 4–7.

9 The ideas formulated in *Aesthetika* were first developed by Baumgarten in his doctoral dissertation in 1735. See *Reflections on Poetry,* trans. Karl Aschenbrenner and William Holther (Berkeley, Calif.: University of California Press, 1954).

10 Shaftesbury, *Soliloquy or Advice to an Author,* pt. 3, sec. 1, as quoted in Ernst Cassirer, *The Philosophy of the Enlightenment* (Boston: Beacon Press, 1951), p. 332.

11 Edmund Burke, *A Philosophical Enquiry into the Origin of Our Ideas of the Sublime and Beautiful,* ed. J. T. Boulton (Notre Dame, Ind.: University of Notre Dame Press, 1958), p. 149.

12 Immanuel Kant, *Critique of Judgement,* trans. J. H. Bernard (New York: Hafner Press, 1951), p. 149.

13 G. W. F. Hegel, *The Philosophy of Fine Art,* trans. F. P. B. Osmaston (London: G. Bell, 1920), 3: 14–15.

14 Ibid, p. 16

15 Benedetto Croce, *Aesthetic,* trans. Douglas Ainslie, rev. ed. (New York: The Noonday Press, 1953), p. 302.

16 Ibid, p. 405.

17 Theodor Lipps, *Raumaesthetik und Geometrisch-Optische Täuschungen* (Leipzig; J. A. Barth, 1897). For a discussion of the ugly and beautiful as properties of empathy, see Ernest K. Mundt, "Three Aspects of German Aesthetic Theory," *Journal of Aesthetics and Art Criticism* 17, no. 3 (1959): 294.

18 Violet Paget [Vernon Lee], *The Beautiful* (Cambridge: Cambridge University Press, 1913), p. 61; Bernard Bosanquet, *Three Lectures on Aesthetic* (London: Macmillan & Co., 1915), p. 24.

19 Geoffrey Scott, *The Architecture of Humanism,* 2d ed. (Garden City, N.Y.: Doubleday & Co., 1954), pp. 171, 173.

20 Adolf Hildebrand, *Das Problem der Form in der Bildenden Kunst,* 4th ed. (Strassburg, 1903).

21 J. J. Gibson, *The Senses Considered as Perceptual Systems* (Boston: Houghton Mifflin Co., 1966), pp. 97–98.

22 Ibid, p. 32. "The observer who is awake and alert does not wait passively for stimuli to impinge on his receptors; he seeks them. He explores the available field of light, sound,

odor, and contact, selecting what is relevant and extracting the information." Gibson goes on to characterize sensing as active, mobile, exploratory, and orienting. He disputes the classical notion of sensing as primarily receiving (with receptors) and characterizes sensory activity as purposive and somewhat aggressive in nature.

23 In his *De Anima* Aristotle dramatizes the inclusiveness of the sense of touch by recognizing its primal indispensability to life:

All the other senses, e.g. smell, sight, hearing, apprehend through media; but where there is immediate contact the animal, if it has no sensation, will be unable to avoid some things and take others, and so will find it impossible to survive. . . . Without touch it is impossible to have any other sense. . . . In the case of the others excess of intensity in the qualities which they apprehend, i.e. excess of intensity in color, sound, and smell, destroys not the animal but only the organs of the sense (except incidentally, as when the sound is accompanied by an impact or shock, or where through the objects of sight or of smell certain other things are set in motion, which destroy by contact). . . . But excess of intensity in tangible qualities, e.g. heat, cold, or hardness, destroys the animal itself.

24 Seymour Fisher, *Body Experience in Fantasy and Behavior* (New York: Appleton-Century-Crofts, 1970), p. 325.

25 Seymour Fisher and Sidney E. Cleveland, focus on boundary characteristics. *Body Image and Personality*, 2d ed. (New York: Dove Publications, 1968).

26 Seymour Wapner and Heinz Werner, eds., *The Body Percept* (New York: Random House, 1965), p. 88.

27 Paul Schilder, *The Image and Appearance of the Human Body* (New York: International Universities Press, 1950), p. 280.

28 Ibid, p. 91.

29 Hartley Alexander, *The World's Rim* (Lincoln, Nebr.: University of Nebraska Press, 1953), p. 9.

30 Robert Thompson, *African Art in Motion* (Los Angeles, Calif.: University of California Press, 1974), pp. 13, 14.

31 Fisher, *Body Experience in Fantasy and Behavior*, p. 473.

32 Wapner and Werner, *The Body Percept*, chaps. 1 and 2.

33 Ibid, p. 24.

34 Fisher, *Body Experience in Fantasy and Behavior*, p. 406.

35 Fisher and Cleveland in *Body Image and Personality* studied the effect of communal behavior on individuals and observed that displays of definite values in parents, for example, have affected the "definiteness" of the body boundary in their children. They also studied the body-image definiteness of entire cultures and noted some curious differences. They cited the Navajos and Zuñis as having developed especially definite body boundaries and observed that the modern Western tradition has the lowest boundary definiteness of the cultures they rated. They suggest that the complex and extreme division of labor might have created forces alien to the formation of strong personal boundaries. (pp. 292–94)

36 Schilder, *Image and Appearance of the Human Body*, p. 218.

37 Ibid.

38 The "physical" body is the private property of the individual, but the individual's body image is developed socially and thus has a social property. The tendency to associate the body with physicality rather than image over-associates the body with notions of privacy.

39 Bachelard, *Poetics of Space*, p. 138.

40 Rudolf von Laban, *Language of Movement*, ed. Lisa Ullman (Boston: Plays, 1974).

41 Peter Cook et al., eds. *Archigram* (New York: Praeger, 1973), p. 124.

42 Christian Norberg-Schulz, in his *Existence, Space, and Architecture* (New York: Praeger, 1971), develops from Martin Heidegger and others a definition of what he calls "existential space" which includes a critically important description of the field in which architecture functions and of the roles of path, place, and domain in our understanding and organizing inhabited space.

43 Robert Campbell, "Kresge College: A Cradle Found in a California Forest," *Boston Sunday Globe*, January 30, 1977, p. C2.

Bibliography

Alexander, Hartley. *The World's Rim*. Lincoln, Nebr.: University of Nebraska Press, 1953.

Aristotle. *Basic Works*. Edited by Richard McKeon. New York: Random House, 1941.

Bachelard, Gaston. *The Poetics of Space*. Translated by Maria Jolas. Boston: Beacon Press, 1964.

Baumgarten, Alexander G. *Reflections on Poetry*. Translated by Karl Aschenbrenner and William B. Holther. Berkeley, Calif.: University of California Press, 1954.

Bloomer, Kent, ed. "Humanist Issues in Architecture," *Journal of Architectural Education* 29, no. 1 (September, 1975).

Bosanquet, Bernard. *Three Lectures on Aesthetic*. London: Macmillan & Co., 1915.

Burke, Edmund. *A Philosophical Enquiry into the Origin of Our Ideas of the Sublime and Beautiful*. Edited by James T. Boulton. Notre Dame, Ind.: University of Notre Dame Press, 1968.

Calvino, Italo. *Invisible Cities*. Translated by William Weaver. New York: Harcourt, Brace, Jovanovich, 1974.

Cassirer, Ernst. *The Philosophy of the Enlightenment*. Translated by Fritz C. A. Koelln and James P. Pettegrove. Boston: Beacon Press, 1951.

Croce, Benedetto. *Aesthetic*. Translated by Douglas Ainslie. Rev. ed. New York: The Noonday Press, 1953.

Doxiadis, Constantinos. *Architectural Space in Ancient Greece*. Translated by J. Tyrwhitt. Cambridge, Mass.: M.I.T. Press, 1972.

Eliade, Mircea. *The Myth of the Eternal Return*. Translated by W. R. Trask. Bollingen series, vol. 46. Princeton, N.J.: Princeton University Press, 1954.

———. *The Sacred and the Profane*. Translated by W. R. Trask. 1st American ed. New York: Harcourt, Brace, 1959.

Fisher, Seymour. *Body Experience in Fantasy and Behavior*. New York: Appleton-Century-Crofts, 1970.

Fisher, Seymour, and Cleveland, Sidney E. *Body Image and Personality*. 2d ed. New York: Dover Publications, 1968.

Gibson, James J. *The Senses Considered as Perceptual Systems*. Boston: Houghton Mifflin Co., 1966.

Giedion, Sigfried. *Space, Time, and Architecture*. 3d ed. Cambridge: Harvard University Press, 1954.

Gorman, Warren. *Body Image and the Image of the Brain*. St. Louis, Mo.: W. H. Green, 1969.

Gregory, R. L. *Eye and Brain*. New York: McGraw-Hill Book Co., 1966.

Hall, Edward T. *The Hidden Dimension*. 1st ed. Garden City, N.Y.: Doubleday & Co., 1966.

———. *The Silent Language*. Garden City, N.Y.: Doubleday & Co., 1959.

Halprin, Lawrence. *The RSVP Cycles*. New York: G. Braziller, 1969.

Harries, Karsten. *The Meaning of Modern Art*. Evanston, Ill.: Northwestern University Press, 1968.

Hegel, Georg W. F. *The Philosophy of Fine Art*. Translated by F. P. B. Osmaston. 4 vols. London: G. Bell, 1920.

Hildebrand, Adolf. *Das Problem der Form in der Bildenden Kunst*. 4th ed. Strassburg, 1903.

Humphrey, Doris. *The Art of Making Dances*. Edited by Barbara Pollack. New York: Holt, Rinehart & Winston, 1960.

Jackson, John Brinckerhoff. *American Space: The Centennial Years, 1865–1876*. 1st ed. New York: W. W. Norton, 1972.

Kant, Immanuel. *Critique of Judgment*. Translated by J. H. Bernard. New York: Hafner Press, 1951.

Laban, Rudolf Von. *The Language of Movement*. Edited by Lisa Ullman. Rev. ed. Boston: Plays, 1974.

Langer, Susanne K. *Feeling and Form*. New York: Charles Scribner's Sons, 1953.

———. *Philosophy in a New Key*. New York: New American Library, 1948.

Lévy-Bruhl, Lucien. *How Natives Think*. Translated by Lilian A. Clare. New York: Washington Square Press, 1966.

Lewis, David, ed. *The Pedestrian in the City*. "Architects' Year Book" XI. London: Elek Books, 1965.

Lipps, Theodor. *Äesthetik*. 2 vols. Hamburg: L. Voss, 1903–06.

———. *Raumaesthetik und Geometrisch-Optische Täuschungen*. Leipzig: J. A. Barth, 1897.

Moore, Charles, and Allen, Gerald. *Dimensions*. New York: Architectural Record Books, 1976.

Moore, Charles; Allen, Gerald; and Lyndon, Donlyn. *The Place of Houses*. New York: Holt, Rinehart & Winston, 1974.

Norberg-Schulz, Christian. *Existence, Space, and Architecture*. New York: Praeger, 1971.

Ortega y Gasset, Jóse. *The Revolt of the Masses*. Translated anonymously. New York: W. W. Norton, 1932.

Paget, Violet [Vernon Lee]. *The Beautiful*. Cambridge: Cambridge University Press, 1913.

Piaget, Jean. *The Child's Conception of the World*. Translated by Joan and Andrew Tomlinson. Tutowa, N.J.: Littlefield, Adams, 1972.

Portoghesi, Paolo. *Rome of the Renaissance*. Translated by Pearl Sanders. London: Phaidon, 1972.

Rapoport, Amos. *House Form and Culture*. Englewood Cliffs, N.J.: Prentice-Hall, 1969.

Rasmussen, Steen Eiler. *Experiencing Architecture*. 2d U.S. ed. Cambridge, Mass.: M.I.T. Press, 1962.

Rudofsky, Bernard. *Streets for People*. Garden City, N.Y.: Doubleday, 1969.

Rykwert, Joseph. *The Idea of a Town*. Princeton, N.J.: Princeton University Press, 1976.

———. *On Adam's House in Paradise*. New York: Museum of Modern Art, 1972.

Schilder, Paul. *The Image and Appearance of the Human Body*. New York: International Universities Press, 1950.

Scott, Geoffrey. *The Architecture of Humanism*. 2d ed. Garden City, N.Y.: Doubleday & Co., 1954.

Scully, Vincent. *The Earth, the Temple, and the Gods*. New Haven: Yale University Press, 1962.

Smith, Earl Baldwin. *The Dome*. Princeton, N.J.: Princeton University Press, 1950.

Sommer, Robert. *Personal Space*. Englewood Cliffs, N.J.: Prentice-Hall, 1969.

Summerson, John. *Heavenly Mansions*. New York: W. W. Norton, 1963.

Thompson, Robert F. *African Art in Motion*. Los Angeles: University of California Press, 1974.

Tuan, Yi-Fu. *Topophilia*. Englewood Cliffs, N.J.: Prentice-Hall, 1974.

Venturi, Robert. *Complexity and Contradiction in Architecture*. The Museum of Modern Art Papers on Architecture, 1. New York: The Museum of Modern Art, 1966.

Wapner, Seymour, and Werner, Heinz, eds. *The Body Percept*. New York: Random House, 1965.

Wertheimer, Max. "Laws of Organization in Perceptual Forms" in *A Source Book of Gestalt Psychology*, edited by W. D. Ellis, London: Routledge & Kegan Paul, 1955.

Wittkower, Rudolf. *Architectural Principles in the Age of Humanism*. 2d ed. London: A. Tiranti, 1952.

Index

Illustration numbers are italicized and placed closest to the page number on which they appear.